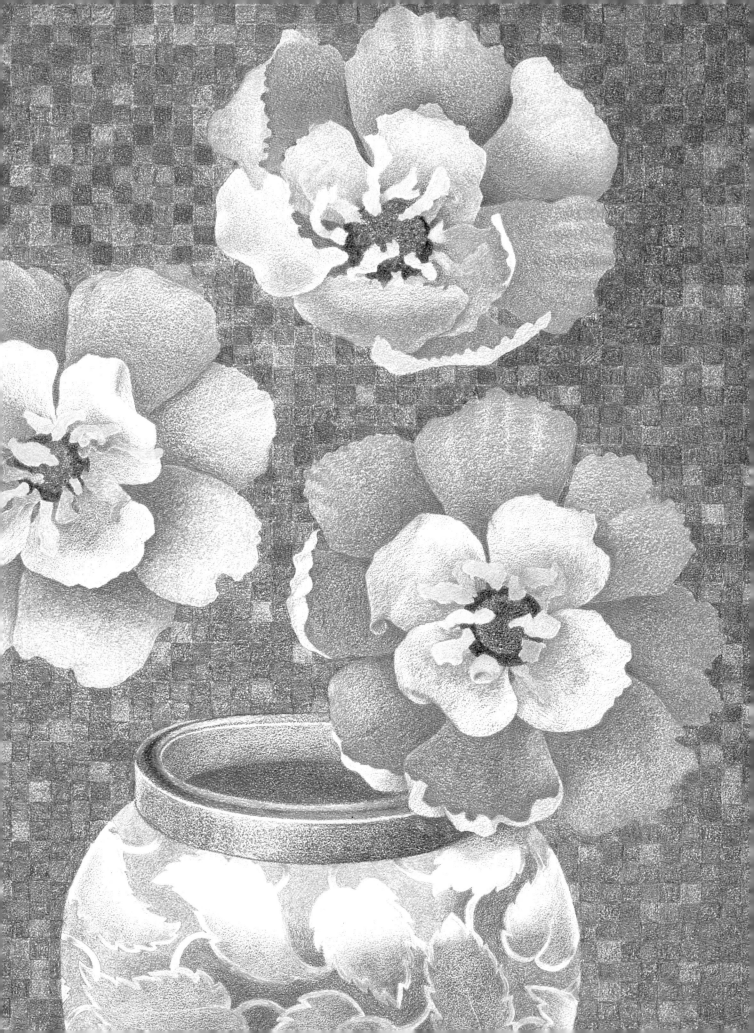

# COLOR DRAWING
# WORKSHOP

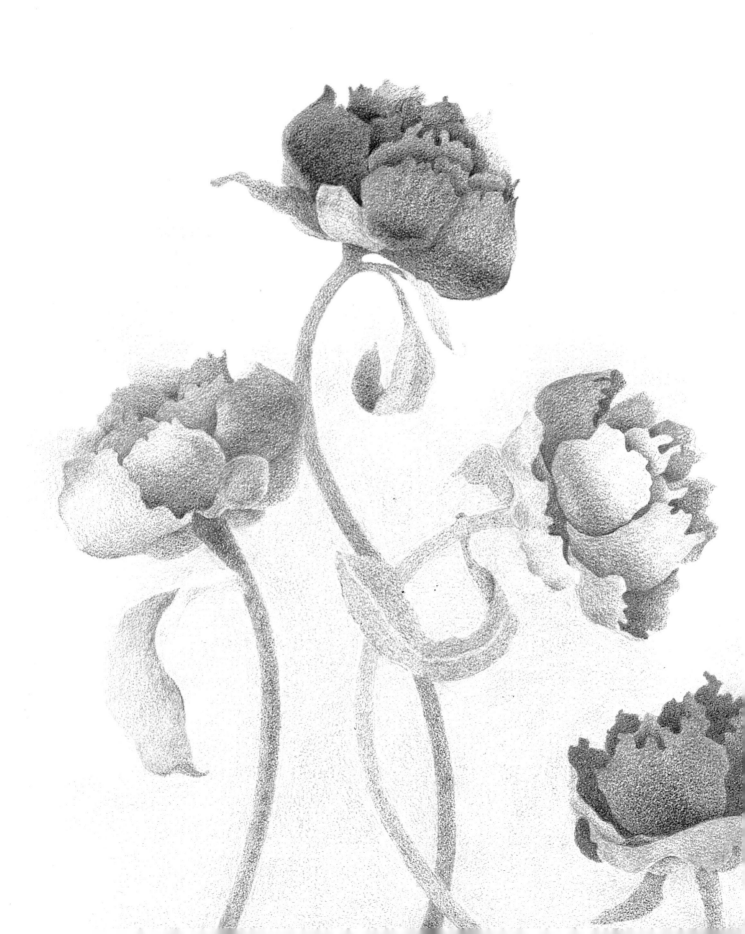

# COLOR DRAWING
# WORKSHOP

## BY BET BORGESON

Photography by Edwin Borgeson

ptill Publications
w York

Copyright © by Watson-Guptill Publications

First published 1984 in New York by Watson-Guptill Publications,
a division of Billboard Publications, Inc.,
1515 Broadway, New York, N.Y. 10036

Library of Congress Cataloging in Publication Data

Borgeson, Bet.
  Color drawing workshop.

  Bibliography: p.
  Includes index.
  1. Color drawing—Technique. I. Title.
NC758.B67   1984      741.2′4      83-27353
ISBN 0-8230-0721-9

Distributed in the United Kingdom by Phaidon Press Ltd., Littlegate
House, St. Ebbe's St., Oxford

Manufactured in Japan.

4 5 6 7 8 9 10/89

*Dedicated to the Memory of*
*Adelaide and Charlotte*

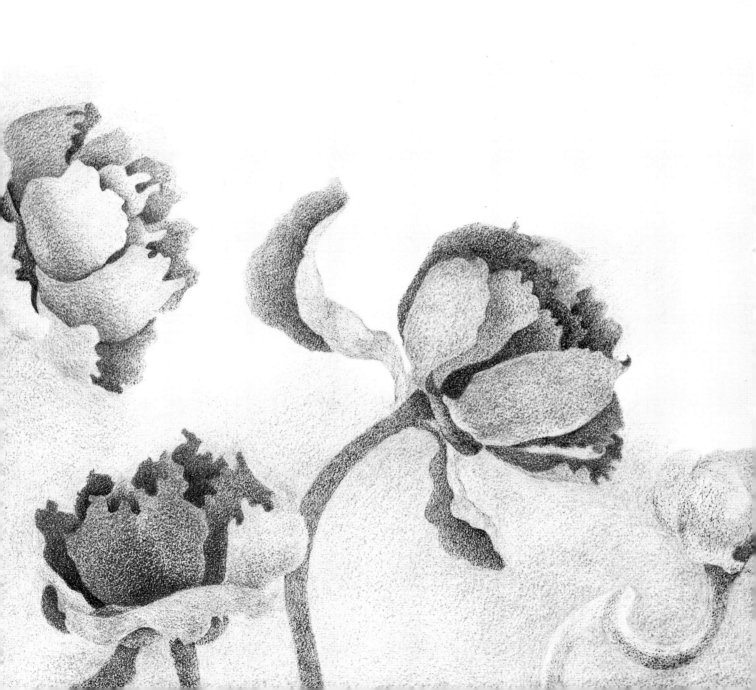

# CONTENTS

# INTRODUCTION

There is a particular kind of aesthetic satisfaction that comes with drawing in color. I think this is because it offers us a way of combining drawing, always at the core of art, with color, used much as it is in painting. And fortunately for us, there has never before been such an abundance of excellent and inexpensive tools available to artists interested in color drawing.

In the practical, "hands-on" pages that follow, we will examine some of the strategies and philosophies, as well as actual techniques needed for good color drawing.

Although drawing concerns are discussed throughout, this is not intended as a how-to-draw book; and some basic black and white drawing experience is assumed. Concerning color theory, less will be assumed, and the usefulness of color's properties will be covered quite thoroughly. This too, however, will be dealt with in as practical a way as possible. It is the hope of this book that by considering some of its approaches to color drawing, and by working with its assignments and projects, you will discover how color and drawing can best work together for you.

# COLOR AND DRAWING

As a beginning for this workshop, I demonstrate that in color drawing the color and the drawing must be regarded as equal partners. Following this discussion, the first five lessons explain and show how color used for drawing is constructed and mixed from line alone, or from a massing of lines into tone. Part one also briefly reviews some of the properties of color itself that we as artists will need to know if we are to excel in color drawing.

# 1. THE COLOR DRAWING PARTNERSHIP

For most of us, learning to draw with color comes *after* we learn to draw in black and white. As a consequence, we easily fall into a habit of feeling that drawing comes first, to be followed by the addition of color as an embellishment. Good color drawing, however, does not work like this. The color and drawing must work instead as an equal partnership, with both contributing fully from a drawing's earliest stages. Without this partnership, we have what is essentially a "coloring book" approach to color drawing.

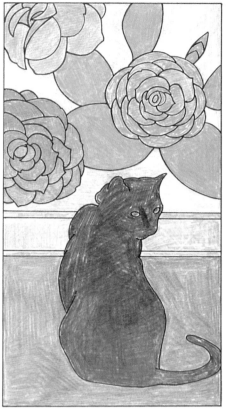

## COLORING BOOK DRAWING

In a child's coloring book, a simple black-and-white drawing such as this cat is considered "unfinished" until color has been added as shown. As artists we must learn to avoid merely "coloring in" our drawings.

## BEGINNING WITH COLOR

The thumbnail roughs show how planning developed for this little color drawing of a cat. My idea was to draw a few fairly simple floral images and then superimpose a sketch of my bored-looking cat looking back over her shoulder at me, instead of toward the flowers, which is what I wanted her to do. In the first thumbnail rough, I tried some complementary colors—among them some natural greens to contrast with the unnatural idea of flowers growing up out of a carpet.

For the second thumbnail; the flower-up-out-of-carpet idea was abandoned, and a warmed-up color scheme tried for a slightly bizarre effect. The receding hues of the first rough were also minimized to suggest a flattening of space. The flowers are planned now for a relationship—by a use of hue—to the wall itself, and might even become some kind of wallpaper.

In the final rough, and the one actually used, a cooled-off color scheme seemed better after all to evoke the mood of detachment I wanted for the cat. I still liked the

idea of flatness of space, but now felt that the flowers should appear to be hovering within it. A vertical pattern for the carpet was planned to help with the flatness part. Getting the flowers (no longer wallpaper) to separate from the background would have to depend—in the actual drawing of them—on attention to color and edge control.

As you can see from this process, my thinking began as much with elements of color as with those of drawing.

## CAT ON BLUE POSIES

*COLORED PENCIL ON PAPER, 5½" × 11" (14 × 28 cm).*
*COLLECTION RICHARD AND MARY MULLER, PORTLAND, OREGON.*

When it is finished, the components of drawing and color contained in a color drawing are more likely than not to be all but inseparable. It is difficult sometimes for even an artist to know at a drawing's completion whether color or drawing arrived first on the scene, or which one motivated the other.

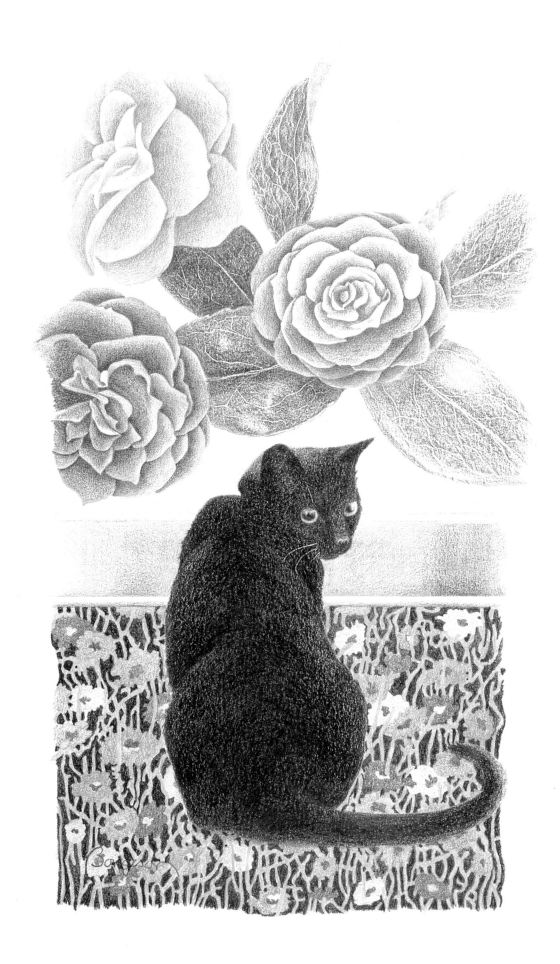

## 2. REVIEWING LINE AND TONE

Line is a vehicle for color. Of course, it is also fundamental to drawing, and with or without color line reveals its own quality or character. But a single line—no matter how expertly drawn—offers color a very limited platform. For this reason, most of our efforts in color drawing must deal not with single contour lines but with a building up of various kinds of tonal area.

### CONTOUR, HATCHING, AND TONAL EFFECTS

In its simplest expression, line delineates contour. This can be used inside or outside a form. The first tulip sketch (A) is drawn as contour only. This does not give us a whole lot of information, but enough to see a form and even a few changes in plane.

When linear hatching is used with contour line, as in the second tulip (B), some additional information is given through some suggestions of light and shade. This addition to contour is a vital com-ponent of traditional drawing.

Although hatching techniques are also linear, they can become so complex and subtle in value gradations that their linear quality almost disappears into tonal expression. This is what is happening in our third tulip (C). Lines are now so densely massed that they have become tone—solid areas of applied pencil. In addition, tone's ability to express texture in a drawing greatly adds to its dimension.

A.

---

### YOU'LL NEED A WORKBOOK

As we go on, I think you will agree it is not enough for me to show you how I do things. An artist needs to experience technique firsthand. You must experience the tools of the medium in your own hand, and how they work within your own drawing style. So before we delve into all the various ways to handle color drawing, I suggest that you fully participate in the process of learning by setting up your very own color drawing workbook.

There will be two kinds of assignments ahead: workbook and drawing. The second of these will measure your progress in color drawing; but the first may turn out to be more important to you, because your workbook is where you will eventually find your swiftest and most intimate interpretations of color drawing technique. In a manner of speaking, it will be a running account of *your* end of our conversations.

In setting up your own work-book, there are two general ways to do it. Some artists prefer a spiral tablet with everything kept intact inside. Another solution is to work on loose sheets of paper, storing them all in an ample-sized folder of some kind. This second approach seems to work best for me. I find it handy for saving all kinds of color and drawing notes, including even a fragment from a failed drawing that remains meaningful to me.

*Note*: I prefer working with colored pencils and hope you too will give them a try if you haven't already. But if you prefer drawing with other color media, by all means do so. The materials list (pp. 136–137) in the appendices contains some of the other excellent color media now available. Of course, the drawing tool you use will also influence the kind of paper or support you need. For drawing with colored pencils, I use a medium-grain paper.

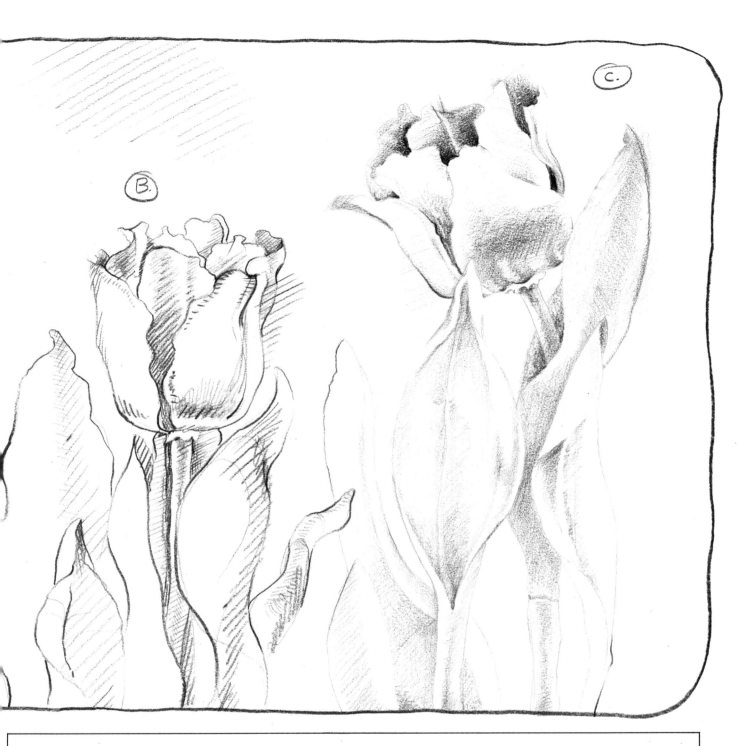

## WORKBOOK ASSIGNMENT

With a dark, soft-leaded colored pencil (not one of the hard, brittle kind), draw some areas of line and tone on a medium-grained paper. Note that a colored pencil immediately feels different on the paper from a graphite pencil.

Draw a tonal band like the one shown (horizontal usually feels more natural), gradually changing its values from dark to light. Don't be afraid to press hard in the darkest area. Artists new to colored pencils sometimes don't realize how much pressure is needed for maximum darks.

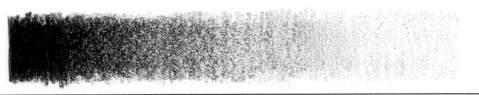

# 3. BUILDING COLOR WITH LINE AND TONE

In color drawing, colors can be built with a few lines or with many lines adding up to a tone.

I almost always draw now with colored pencils. What attracts me most is their semi-opacity or near-transparency. Besides allowing me to mix colors by juxtapositioning, as is done with most color drawing media, colored pencils also allow me to superimpose colors for some particularly complex and subtle new mixtures.

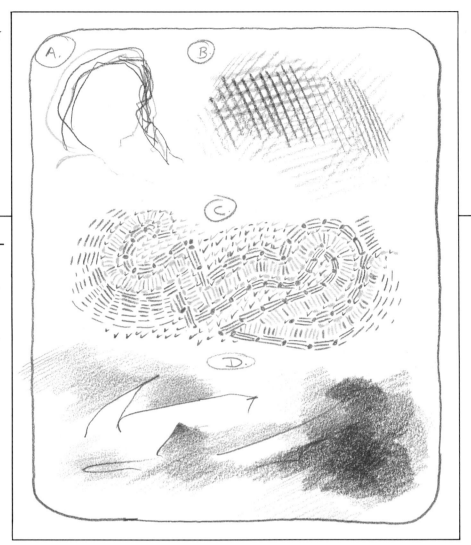

## WORKBOOK ASSIGNMENT

Building up your own color mixtures, rather than relying on the colors contained in specific pencils, will mark your entrance into a much more sophisticated color milieu. Practice mixing some colors, using these swatches as guides.

A. Freely draw a few contour lines with different colors, letting them overlap. This linear bundling is a very dynamic and direct way of mixing color.

B. Try hatching and cross-hatching with different combinations of pencil hues.

C. Make a free-form pattern by juxtaposing marks of color. All of these first three examples rely on the juxtaposition of colors for their mixing effects.

D. Layer one pencil color over another until a solid new area of tone is established. Experiment with the shaft of a pencil's lead as well as its point. It is in tonal work such as this that you'll begin to appreciate the importance of paper texture.

In the close view of example D, you can see how mixing occurs when one transparent color is overlaid on another. Sometimes an unmixed pencil hue seems exactly right for a passage being worked; more often, however, the desired color can only be achieved by personal mixing.

## OVERLAYING COLOR

The overlaying of color can be seen in this drawing still in progress. At this point, red-orange is being added to warm up the foreground. Those tornadolike bands of blue dipping down from the sky are actually just the beginning of color mixing in that area. I am purposely disregarding contour or boundary edges with this new layer of blue, because I want it to help integrate hills and sky.

## DRAWING ASSIGNMENT

As your first color drawing assignment, I would like you to try a "minimal landscape." This is a kind of drawing in which you *must* subordinate drawn detail to color mixing—and to building color with line and tone. You can see examples of these things in this student's drawing (lower right).

1. Beginning with a graphite (ordinary drawing) pencil and a sheet of medium-grained drawing paper, *very lightly* organize your space into an imaginary landscape. Any trees or structure included must be thought of as *very simplified* versions, with no detail of any kind expressed.

2. Start laying in color. Remember your different options for combining colors. Work slowly. Talk to yourself about what you are doing, and what is happening on the paper. Be a scientist—be curious. Mix your colors for this landscape almost at random. You will probably be surprised with this approach at how true-to-nature your color mixes will be. Save this (and all your finished drawings) for future reference.

*STUDENT DRAWING, Lawrence Begley. Colored pencil on paper.*

# 4. SORTING OUT SOME COLOR BASICS

For a long time, I did my best to avoid really learning color theory. Somehow, it didn't seem to have much to do with art and it seemed difficult as well. Besides, all I really needed, I felt, was a liking for color and my own intuition. Time passed, and I continued to paint and draw; but I gradually grew aware of two curious things. One was that I never had much luck at predicting final color results. The other was that I seemed to be relying, over and over again, on the same old color mixtures.

If you haven't yet come to grips with the basics of color, start doing it now. You will never regret it. I know that for me, the payoff has been not only a breaking away from limitations, but a giant step forward in confidence.

The following covers some essentials about color that you should be aware of.

## HUE

All colors have three dimensions. Hue is one of these. (Value and intensity are the other two). Hue identifies a color by its name—yellow, blue, red-violet.

Hue is also dynamic, and can be subjective. The human eye is believed to be most sensitive to yellow, and least sensitive to red. There is some evidence, in fact, that we don't see true red at all; and having seen red only as a cherry-red or orange-red, we cannot visualize a red that doesn't lean toward blue or orange. Each hue appears to exist for each of us in our eye, our brain, and our memory—and nowhere else.

The difference between *hue* and *color* (often used interchangeably) is that color contains all three dimensions (hue, value, and intensity) while hue, *as one dimension*, is only a part of color.

## NEUTRALS

These are mixtures that contain no hue. They are black, white, or gray.

One axiom of color theory is that when complementary colors are mixed in equal proportions, the result is a neutral. In actual practice, however, it is a near-impossibility to find *exact* complementary

color pairs, or if in fact they seem to be found, it is even more difficult to overlay or blend them in *exactly* equal proportions.

## VALUE

Value is another of color's three dimensions, and refers to the lightness or darkness of a hue. It is the only dimension of the three that can also exist outside of color (as a neutral).

When you are thinking in terms of value, *low* means dark, and *high* means light. Try not to confuse value with intensity (color's dimension of brightness). Incorrectly reading color values lies at the heart of many failed drawings. Too many unrelated dark values in a single composition, for example,

usually result in a colorful looking but scattered and disjointed effect.

## LOCAL COLOR

This term refers to the actual color of something: a blue sweater, a yellow fence, red lips. The play of light can change local colors. So can we as artists (for one reason or another) interpret local color any way we choose.

## LOCAL VALUE

Similar to local color, local value refers only to value. It is a thing's *basic value*, apart from any apparent changes made by lighting. Local value must not be confused with uses of light and shade for modeling—which shows form through value changes.

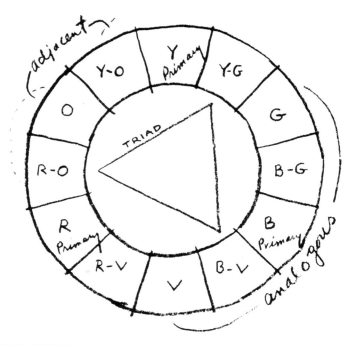

## THE COLOR WHEEL

For me, the least confusing color wheels are those shown only as diagrams that contain no color. Color wheels, after all, are supposed to be conceptual tools. Their purpose is not to show us what colors look like but rather to show us color relationships.

A quick way of seeing some of these relationships is with the hue-initialed, twelve-hue wheel sketched here. *Complementary hues* are those opposite one another, *adjacent* hues are those next to one another, and *analogous* hues are any neighboring

groups of similar hue. The triangle in the middle indicates a *triad*. As it revolves (in this color wheel) it always points out a triadic relationship.

The reason artists like to refer to a color wheel (instead of a more scientific, stretched-out band of color wavelengths) is that it lets us see color relationships at a glance. Should we temporarily forget, for example, that the *near-complementary* hues of blue-violet are orange and yellow, the wheel will let us know instantly.

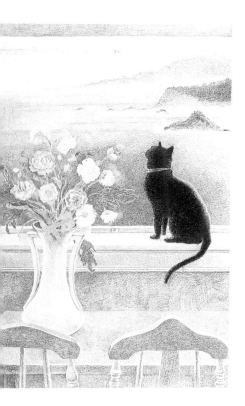

## MIXED OMENS

*COLORED PENCIL ON PAPER, 10" x 13½" (25.4 x 34.3 cm). COLLECTION SUZAN DAHLSTROM, PORTLAND, OREGON.*

Here is a drawing of mine that contains a value flaw. The error happened because even though the drawing's values fall mostly in the middle range, the cat—being in real life a black cat—was firmly drawn as such. This sets up a contrast in value that rivets our attention but discourages our eye from wandering throughout the rest of the composition. There is simply no preparation for the sudden blackness of the cat.

The sketched version shows how a better use of values might have improved this drawing. A connected series of dark-valued elements begins in the lower left corner, moves up the wall, and turns toward the cat before continuing on up and out of the picture. This use of value would probably have helped the composition, as well as relieving my much too literal report of a black cat on a sunny windowsill.

# SORTING OUT SOME COLOR BASICS

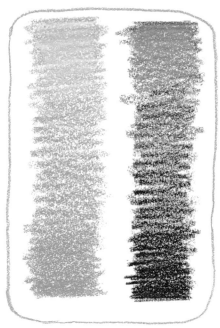

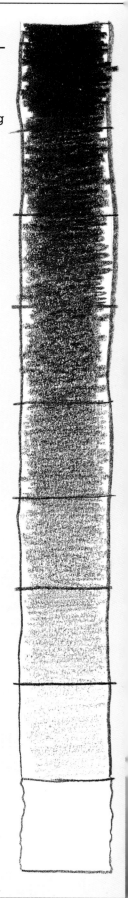

## INTENSITY

This is the third of color's dimensions (besides hue and value). It refers to the brightness or dullness of a color. Another word for it is *chroma*.

Color is usually considered to be at its brightest (most intense) when pure and unmixed—and to get less bright the more it is mixed with another color or neutral. But this does not mean that mixed colors cannot remain bright. For example, the green swatch shown here in a yellow-orange field is a mixture of three colors, while the yellow-orange contains only two— and the green still looks brighter than the orange.

Other words used for bright (in intensity) are saturated, brilliant, pure, and high-intensity. Try not to confuse bright (intensity) with light (value), or dull (intensity) with dark (value).

## COLOR TEMPERATURE

Colors also seem to us to have temperature: those near red, we consider warm; those near blue, we consider cool. But this perception of temperature also depends largely on context: the green band shown appears warmer at yellow-green (toward red on a color wheel) and cooler at true green (toward blue). The orange-red band, however, stays warm from top to bottom, despite its hue changes, because it is made up of two hues that are basically warm.

## WORKBOOK ASSIGNMENT

Make a nine-segment value chart of graduated neutrals. On paper, using a black from your preferred medium, mark off nine squares. Make a segment at one end as black as you can. Leave a segment at the opposite end blank, representing pure white. Fill in the other seven segments as a series of grays, from almost black to almost white. Take your time with this, as you want the progression to be as even as you can make it.

# 5. ESTIMATING A COLOR'S VALUE

When you draw with color, it becomes increasingly important that you learn to see past a color's hue and intensity to its value. This can present a problem, because although it is easy to see values that range from light to dark on a scale of neutrals and almost as easy to devise a scale of values for a single hue, this is not how color values occur as you observe them in the real world.

In reality, you must cope with a jumble of values thrown together with a similar variety of hues and intensities. Arranging color values such as these into an orderly progression from light to dark takes a little doing.

A method that has helped me learn to estimate a color's value under such circumstances is what I call "squint-scan-compare." Squinting at a color will usually reduce its hue and intensity. Scanning quickly across it, and back and forth to the colors and neutrals around it, then makes it possible to estimate its true value. You'll need a bit of practice for this method of determining value.

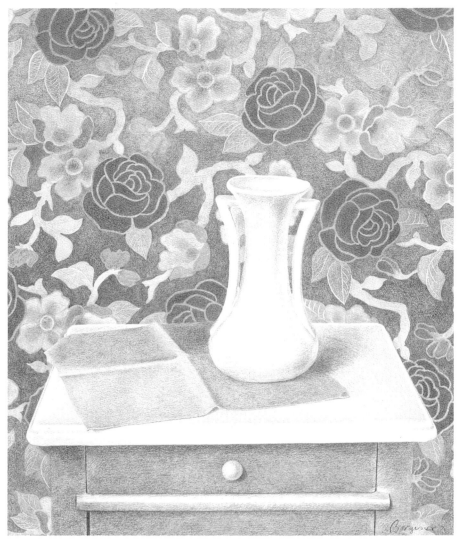

## EMPTY VASE
*COLORED PENCIL ON PAPER, 14" x 17" (35.5 x 43.1 cm).*

You can improve your ability to think effectively about color if you practice "reading" color. As an example of such "reading," look at this drawing of an empty vase.

The first thing you see is the relative color complexity of its background. The colors of the floral pattern are triadic, which means they were mixed from three hues (remember the triangle in our color wheel?). In this case, the hues used were red-violet, yellow-orange, and blue-green. The values and intensities of the pattern elements have been kept closely related, which helps them stay on a single plane. The flowers of the background, however, are warmer in temperature, which causes them to project forward.

There is more, of course, to thinking about color, but you get the idea. As you draw, always try to think of your own colors this specifically. Consider their dimensions and characteristics besides those of hue. And as you encounter color drawing problems, you will find that a correct reading of color properties will almost always help with decisions.

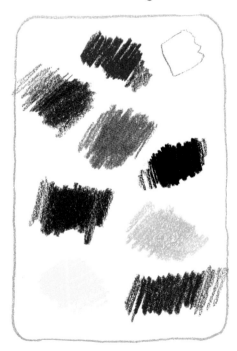

## EXAMPLE

These color swatches represent a possible array of colors encountered in real life. Can you arrange these colors on an accurate value scale?

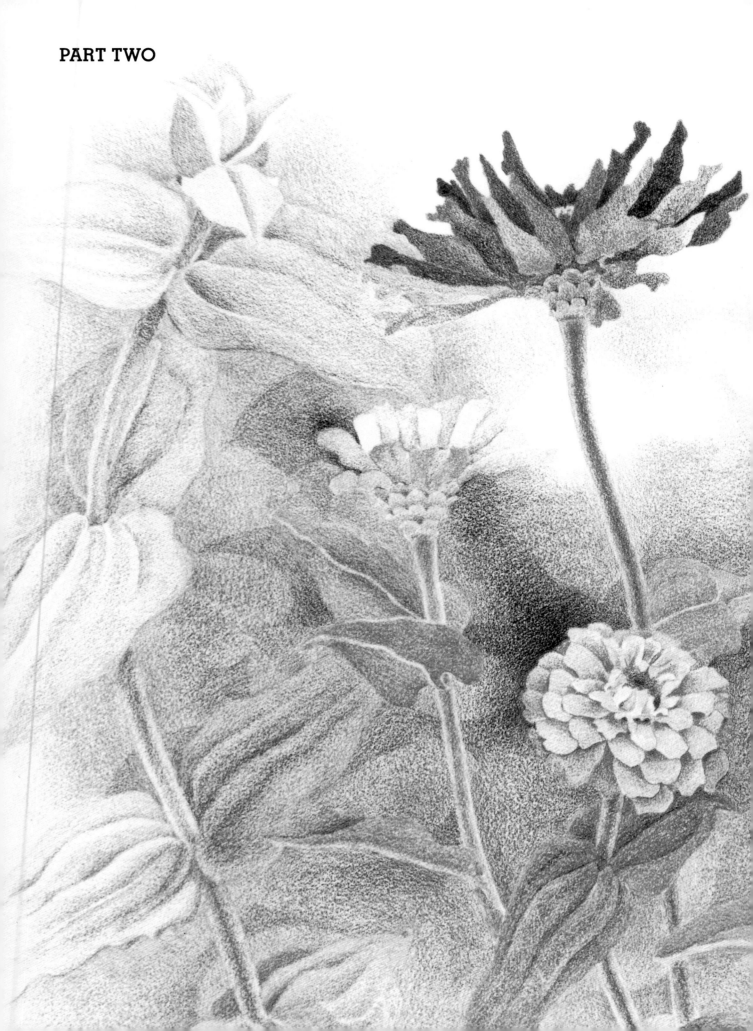

# DRAWING WITH A COLORIST APPROACH

With this group of lessons, we take up strategies for entering a colorist milieu. We will discuss and illustrate some of the pivotal concepts for thinking and working as a colorist. These include uses of color to position elements spatially—to make things advance and recede. We will also deal with modeling with light and shade, and how color can influence this. We will show how line character combined with a keying of color values can influence mood, and we will look closely at what is meant by the "pushing" and breaking up of color in colorist terms. Finally, we will look at some specifics of mixing analogous and near-complementary colors, and at how to keep neutrals hue-laden.

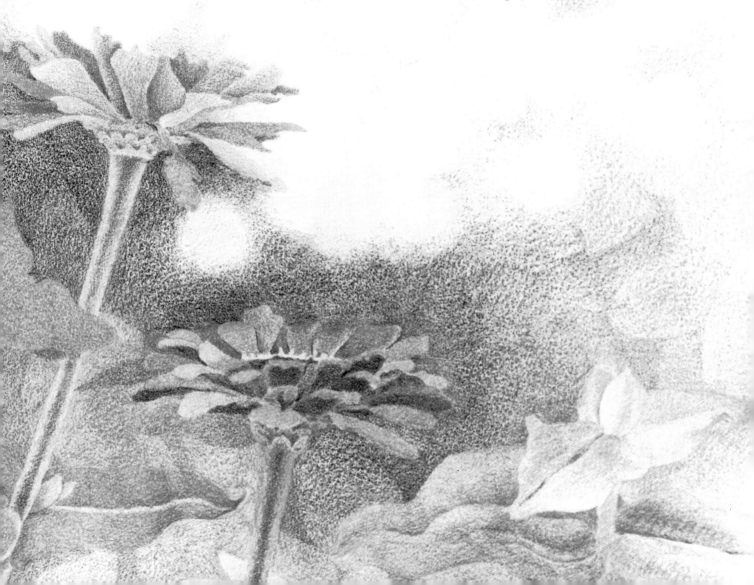

# 6. USING COLOR FOR STRUCTURE

When used to describe an element in art, the word *structure* usually refers to a drawing's total organization of space. As we continue in this workshop, this word will surface for us in a variety of ways. But right now, let's talk about structure in terms of spatial relationships and color.

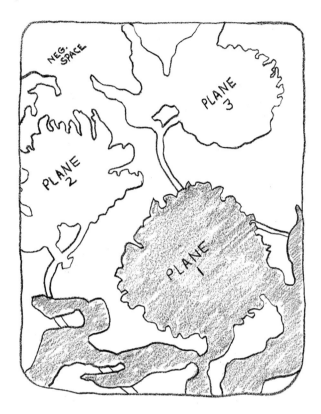

PLANE DIAGRAM

Shown here in diagram form are the three major planes plus the negative space of the drawing *Trio.* The shading of plane 1 clearly shows it overlaps the other two, which is the first clue that it is in front of the other planes. In this drawing, depending on color choices, either of the two rear planes could have been shown as farthest back.

TRIO
*COLORED PENCIL AND ART STIX ON PAPER, 9" x 12" (22.8 x 30.5 cm).*

Here is a drawing that clearly shows a colorist approach to its structure. As the color scheme and the positioning of its main elements were worked out with thumbnail roughs, I began to see that this drawing contained three major planes plus a negative space. While I frequently try to compress space in my drawings, I still want to symbolize some progression of depth.

To make color do this kind of work—and do it in a gentle and natural way rather than in a strident one—I rely mostly on the value, intensity, and temperature of colors. I am less concerned with their hues, particularly as these relate to local color.

To see how a near plane was partly emphasized, look at the lower-right flower. Its petals were rendered in bright warm colors, which brings them forward. By contrast, the flower above it, which is to occupy the plane farthest back, is rendered in much duller and cooler colors.

Value also plays a part in the separation of these two planes. What I did here, in fact, was use value contrasts in the manner of what landscape artists call aerial perspective. Value contrast was kept slight within the rear flower's form, as well as between the flower's form and its surrounding negative space. The front flower, on the other hand, was given a great deal of internal value contrast, and is in much sharper contrast with its negative space.

The flower at left, which occupies a space somewhere between the other two, contains color elements from each of them. It is also brighter in intensity than the back flower, but not as bright as the front one.

See what else you can "read" here of color and structure. What about hue contrasts between the negative space and the flowers?

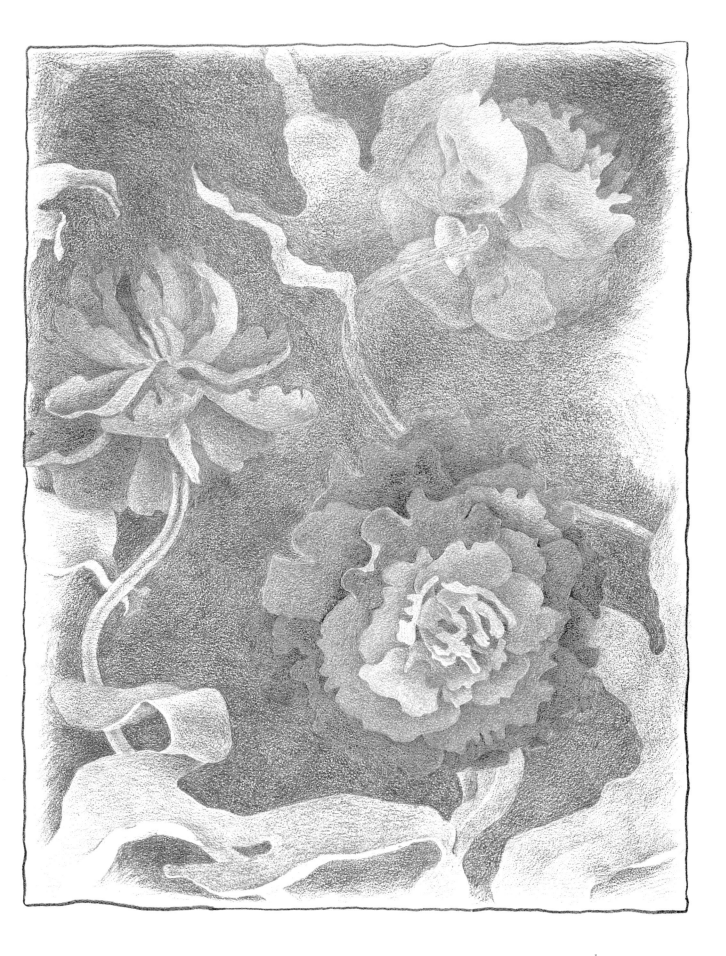

# 7. MODELING WITH LIGHT AND SHADE

So far, I have been talking about color and structure in terms of space, but I haven't included much about color's influence on form. The best way to begin this subject, I think, is to look first at how form is expressed without color. We can learn a great deal about this from classical modeling.

It comes as a great surprise to many to learn that even the most realistic of artists seldom draw what they see. What they actually draw is, more frequently than not, based on a knowledge of certain conventions worked out long ago by the great masters of drawing.

These conventions show a play of light on shapes or forms to reveal them in convincing ways. The reason this has seemed necessary is that any light under which we see things (however carefully arranged) can confuse and minimize form as well as reveal it.

The first thing you will find, if you are new to classical modeling, is that you must give up dependence on your actual light for showing the shapes of things. You must also be willing to dispense with most cast shadows (which tend to obliterate forms behind or under them). But your reward for learning this kind of drawing—whether you ever consciously use your ability at it or not—will be a sure knowledge from now on of how to render three-dimensional form. And modeling with color is also based on modeling with light and shade.

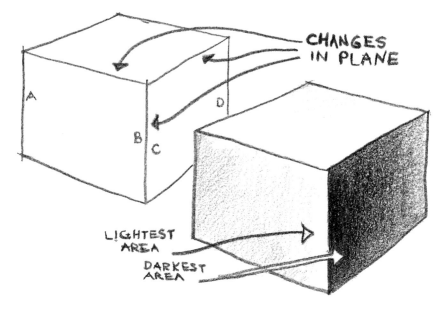

## DIAGRAM 1

Modeling with light and shade is simple when plane changes are abrupt. We see angular shapes in this way almost intuitively. Light in this cubelike shape is shown to grow progressively lighter from A to B, and shade to grow darker from D to C. The greatest contrast between light and shade occurs where these two planes meet.

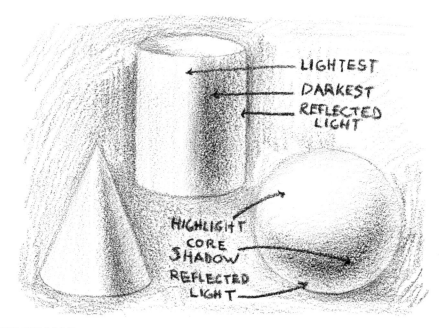

## DIAGRAM 2

A similar treatment of light and shade is used in classical modeling for nonangular shapes. Plane changes for these, however, are rendered less suddenly, with the darkest shadow occurring somewhat past an imaginary meeting of planes in what is called the core shadow.

Compare the more subtle plane change on the cylinder's face with that of the cubelike form. Notice also how easily our sphere could become an egg, an apple, or an eyeball. Check your understanding of all this by naming what you can now identify of the light and shade on the cone.

## EXAMPLE 1

Here is another example of classical modeling, a sketch made after a Rubens study of a young boy's face. The forms of the face are more complex than those we have been talking about, but if we look closely we can find some similarities. There are spherical shapes in the cheeks and chin, in the eyes and beads, and in the head as a whole.

Notice how much the modeling of these shapes resembles the modeling of our simpler shapes. The side nostril facing us clearly shows a progression of highlight to core shadow to reflected light. Another point about this area—and one that often identifies classical modeling—is that there is practically no likelihood of this actually having been on the model's face—it has been added as a symbol or convention of form.

From time to time, practice making sketches from master drawings. The idea is not that you will make close facsimiles. It is that you will personally experience, with pencil in hand, how some of the problems of rendering form have been solved.

## EXAMPLE 2

Look around you for woodturnings to model. The one shown here is a leg on an antique table. A variety of inexpensive turnings can also be found in do-it-yourself or home repair stores.

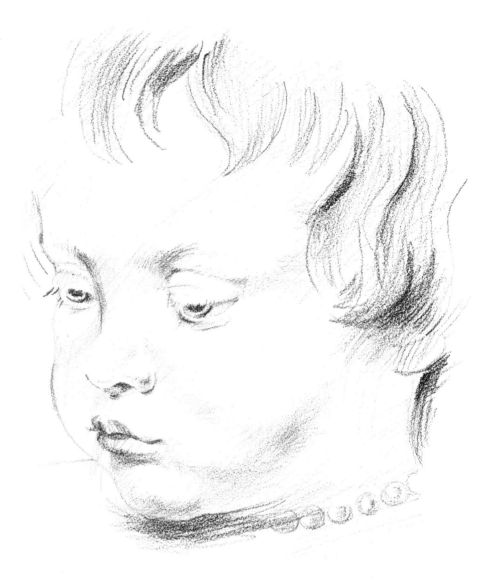

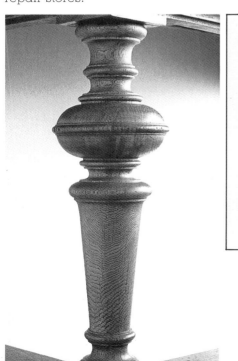

## WORKBOOK ASSIGNMENT

In your own workbook, with a black colored or graphite pencil, draw some simple shapes, then model these with classical progressions of light and shade. Start with a cube shape for its abrupt plane changes. Note the softer progression of value changes you need as you render cylinders and spheres.

Avoid complex forms for now, as you can arrive at these through means other than clas-sical modeling. Simple forms will better prove to you that you understand the concept.

Next, try this kind of modeling on something from life. Some good forms to start with are compound woodturnings. Their stacking of shapes encourages consistent value changes from form to form. They also are usu-ally gentle enough in reflectivity to minimize the influence of lo-cal light.

# 8. MODELING WITH COLOR

Let's look now at modeling with color. There are many ways in which colorists approach this problem. Some have been extensively worked out and are widely known; others remain very personal. But most of the ways of modeling with color can be related to one or another of the following three approaches.

## COLOR MODELING METHODS

In all these sketches of D'anjou pears, the idea is to establish a sense of form and volume. The small pear (A) does so without color, by modeling with light and shade.

The next pears (B) show how a tentative kind of color rendering can evolve. This is a frequent beginning method of using color in drawing. But what are we really looking at here? The two pears are essentially a black-and-white drawing with color added. Compare the similar use of values in the small black-and-white pear with that in the upright green pear. Color in this kind of drawing also usually relies heavily on local color. It is a method of color drawing that can carry conviction, and sometimes it is useful, but it lacks complexity and subtlety.

Another method of color modeling (C) creates form and volume with the intensities and temperatures of hues. Value changes are minimized, or not used at all. This is a dynamic way of modeling form, but is a somewhat rigorous approach to the uses of color. An impression of volume is created by contrasts set up between cool and warm color temperatures and between dull and bright intensities. Cool/dull colors are placed where receding effects are wanted, and warm/bright colors used for placing planes forward.

In the last two pears (D), light and shade modeling (A & B) is combined with some color modeling (C). Value changes are used in the basic rendering of form, although (unlike B) local color was not of great concern. Colors were chosen instead more for their abilities at helping the forward and rear planes advance or recede.

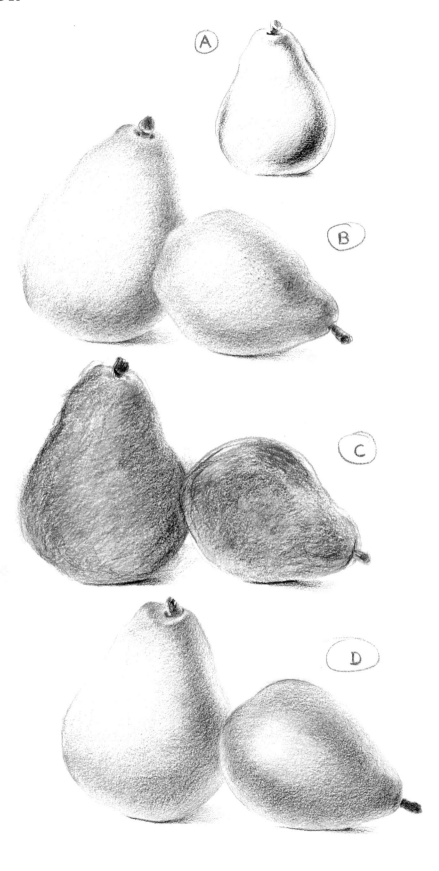

28

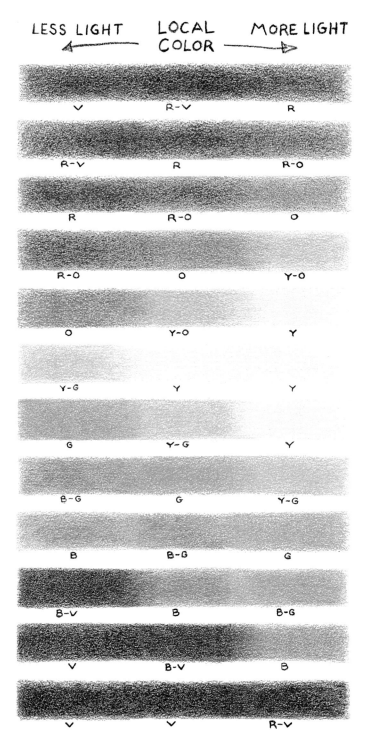

LESS LIGHT ← LOCAL COLOR → MORE LIGHT

| | | |
|---|---|---|
| V | R-V | R |
| R-V | R | R-O |
| R | R-O | O |
| R-O | O | Y-O |
| O | Y-O | Y |
| Y-G | Y | Y |
| G | Y-G | Y |
| B-G | G | Y-G |
| B | B-G | G |
| B-V | B | B-G |
| V | B-V | B |
| V | V | R-V |

## CHANGING COLOR TEMPERATURE

A color's hue is almost always affected by the amount of illumination on it. As the light on a hue increases or decreases, the hue will shift toward its next warmer or cooler adjacent hue on the spectrum. This phenomenon is of enormous importance in color drawing because by understanding and using color to convey temperature, we can suggest the amount of light falling on objects through color alone. If in drawing a sphere, for example, we show a progression of hue temperature changes from cool to warm to cool, we can help to express form by suggesting varying amounts of light.

Shown here are the shifts in color temperature found in the twelve hues of a color wheel.

## DRAWING ASSIGNMENT

Experience for yourself the modeling of form with changes in color, rather than only changes in value.

STEP 1—Set up some small objects near your drawing area. Pick uncomplicated shapes, without much detail. Fruits and vegetables are good subjects. If you set up a light, be ready to override it.

STEP 2—Gather your colors. You'll need two or three to represent local colors, and some warm and cooler versions of these.

STEP 3—With graphite or one of the local colors, lightly draw contours of your objects. As you do this, you should begin to feel where shapes bulge or expand, or planes change.

STEP 4—On scratch paper, restate as a thumbnail what you have drawn, and darken areas you decide will be plane changes. This step helps work out how and where color modeling starts on a drawing.

STEP 5—Working within your own style, begin modeling forms with color. In rear areas, and on or near outside contours, use your coolest and/or dullest colors. For areas in forward planes, or those representing fullest parts, use warm or bright colors.

Local color can also be worked into all areas, but try not to depend too much on them. Whether you end by modeling only with hue changes (as in the pears at C) or use both hue and value changes (as at D), is not too important. What is important is that in this drawing you make color do as much as you can of the work of rendering forms.

# 9. EXPRESSING MOOD

A drawing's mood or attitude is what that drawing is really trying to say to us. Its expression of a mood—as constructed by artist and seen by viewer—is often the major reason a drawing is remembered, or was even made.

Although mood can and sometimes does derive from a drawing's subject, it doesn't necessarily have to; it is usually much more directly the result of how a subject has been handled. In broad terms, there are at least four components in a drawing besides subject matter that influence a drawing's mood. These are:

*Character of Line or Tone*—how the mark of drawing is made

*Composition*—the arrangement of a drawing's elements

*Overall Value Key*—high, low, or medium

*Color*—with all the characteristics and emotional overtones possible

Our strategies for expressing mood will deal mostly with what these things mean to color drawing, with line and tone regarded for the most part as carriers of color. But before we get into this, let's take a beginning look at the first two components in these black and white sketches.

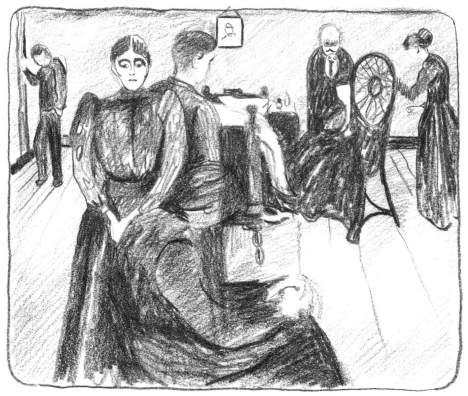

## SKETCH 1

The subject of this sketch, after the painting *Death in the Sick Chamber* by Edvard Munch, may first appear to be its mood of grimness and alienation. But as we study even this black-and-white version, we see other things contributing to its mood. The most important of these is composition, with its arrangement of figures through connecting dark values.

## SKETCH 2

The dark mood expressed in this sketch, modeled after a nineteenth-century drawing by Theo van Ryselberghe, has no obvious source in its subject: a woman seated at a piano can as easily evoke a very lighthearted or cheerful mood. Here, the mood expressed is based not on subject, but entirely on handling. Line quality plus overall low-keyed values are what tell us how to feel about this drawing.

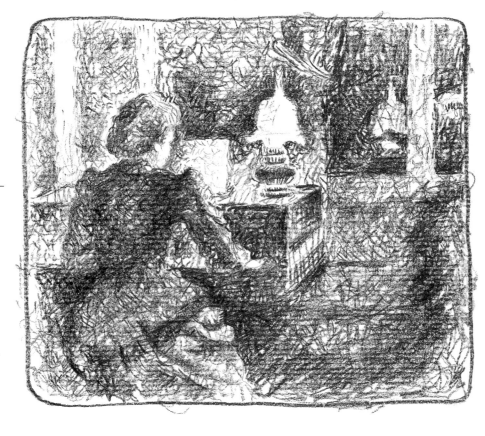

## LINE CHARACTER

Here are some of the marks I use at various times in various ways. In these examples, most were made with a black colored pencil. Exceptions are A, which was made with a felt-tipped marker; B, made with a Prismacolor Art Stix; and C, made with a soft pastel.

As you can see, marks indicate different levels of energy and purpose. If they are also revealing of attitude, it is because they are meant to be—the mark made on paper can be very helpful to us in evoking mood or attitude.

Another thing to consider about marks as a means of expressing mood is their consistency or unity within a drawing. Try to use them with deliberate intent. For my own purposes, when I am attempting to establish a mood of detachment or coolness, I rely a great deal on the kind of mark shown in the upper right-hand corner. By unintentionally combining this mark with the more gestural mark at lower left, I could suddenly (and maybe unwittingly) be working at cross purposes to my true intent.

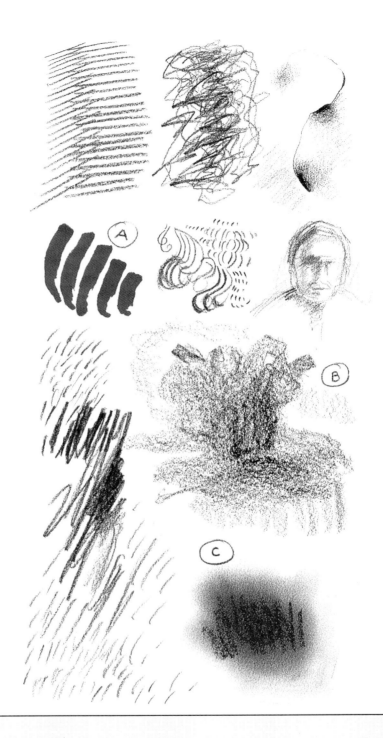

## WORKBOOK ASSIGNMENT

Drawing *is* the making of marks. In your workbook, make a quick mark. Don't try to *intend* any special thing. Make a few more, still quickly, but try to have each be different from the others.

Now look at the marks you have just made. Ask yourself what is different about each from the others. As artists, it is of vital importance that we become sensitive to small nuances.

Try talking to yourself about your marks. Do any of them seem to you suggestive of anything? Can any be called by names that their fellows cannot—like sassy, insipid, dumb, lively? With practice, a mark can be made to suggest such things.

Don't hesitate to spend a few pages of your workbook at nothing more than making marks, particularly with some of your color tools. Put marks in very small spaces—about an inch across—as well as on very large sheets. Practice isolating some marks, and letting others build up in combinations. Your growing skill at handling marks will add a great deal to your graphic vocabulary.

# 10. DRAWING IN HIGH KEY

High-key color drawings have most of their values at the high or light end of our value scale. Dark-valued colors are played down or replaced with colors of greater intensity. However, a high-key drawing can sometimes vitally depend on a carefully planned use of small but very dark values.

Light color values are often considered a sure way of suggesting an upbeat mood of lightheartedness or optimism. They can also suggest other moods, such as longing or nostalgia, or even that things are merely somewhat antiseptic.

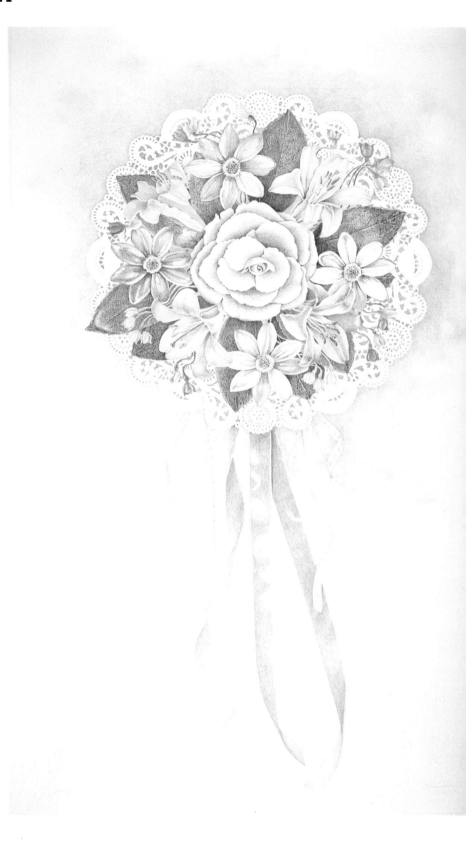

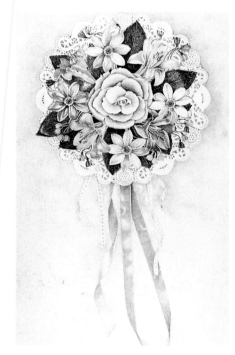

## FLOWERS AND MAKE-BELIEVE
*COLORED PENCIL ON PAPER, 17" × 28"*
*(43 × 71 cm).*

The mood of this high-key drawing was planned as a combination of optimism and naiveté. To this end, light-valued flowers and ribbons were arranged with a similarly light-valued paper doily in a manner suggesting a wedding bouquet. The blue, negative space surrounding the objects in the center was also kept light in value.

The only really dark values are those of the leaves. Contrasts set up by them—better seen in the black-and-white version—were planned to help delineate the forms of the flowers, and also to help make all the light values seem even lighter.

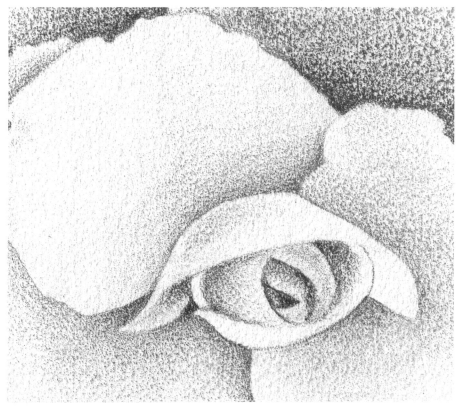

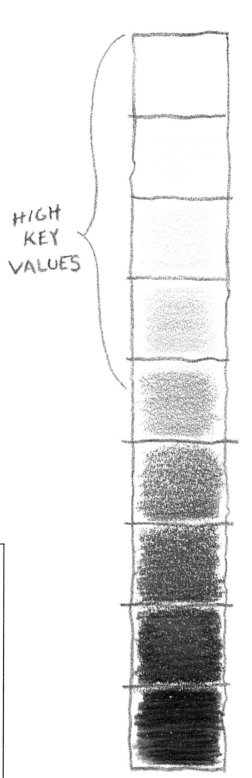

## DETAIL

Controlling gradations in very light values is difficult to do with any drawing medium. An even gradation is shown in this close-up view of the drawing's central flower. One way of making such a task easier is to have adequate support for paper and arm. But here is another tip: experiment with rendering the values you want. If they are not laying down as smoothly as you hoped, make them a trifle darker, then lighten them with an eraser. With colored pencil, pastel, crayon, and color sticks, a kneaded eraser can quickly even tones out by lifting away enough pigment to return a medium value back to a lighter one.

## DRAWING ASSIGNMENT

Our goal this time is to deliberately influence the mood of a color drawing by the use of high key. A good subject is a room, or part of a room, with which you are familiar.

Start by looking calmly and carefully at your subject. Familiar places are sometimes hard to see objectively. Try to see what mood exists now—if any—that you may have to work against. Decide as specifically as you can what it is (optimism, austerity, or whatever) that you want your high values to express.

Three things you can do to further a high-key effect are:

1. Lighten or eliminate cast shadows wherever these exist.

2. Try to substitute intensity of color for darkness in areas that resist great rises in value.

3. Select one or two small areas to render very darkly. Small, sharp contrasts can punch up or emphasize your overall lightness of value.

When you have finished, don't be too quick to reject your own success. Often, the conveyance of mood can be subjective and very subtle. See if a friend can guess the mood of your drawing.

## VALUE SCALE

The high-key values of a constructed blue hue can be readily seen in this nine-step value chart.

33

# 11. DRAWING IN LOW KEY

Low-key drawing—with mostly dark values—is often used for grave or heavy moods. And color drawing media is good at working in low key. Unlike traditional graphite pencils, which by their nature read almost always in light-to-medium value ranges— most color drawing media excel at yielding rich and hue-laden dark values.

## DARKENING COLORS WITH COLOR

In color drawing, it works best to lower color values by adding darker colors rather than adding neutral blacks. This is what yields hue-laden dark values. Here are some value scales showing examples of this:

Scale A, made with a single colored pencil (Prismacolor 924 Crimson Red) contains no added darkener in the blank squares; its darkness ends with this color's own inherent darkest value. In scale B, this same red is further darkened by mixing it with a 901 Indigo Blue. In scale C, it is darkened with a 908 Dark Green.

In scales D and E, a 931 Purple is darkened first with a 901 Indigo Blue, then with a 935 Black. The last scale, F, contains a 907 Peacock Green darkened with 901 Indigo Blue. Try some of these yourself for a better look at their subtle superiorities to neutral darks.

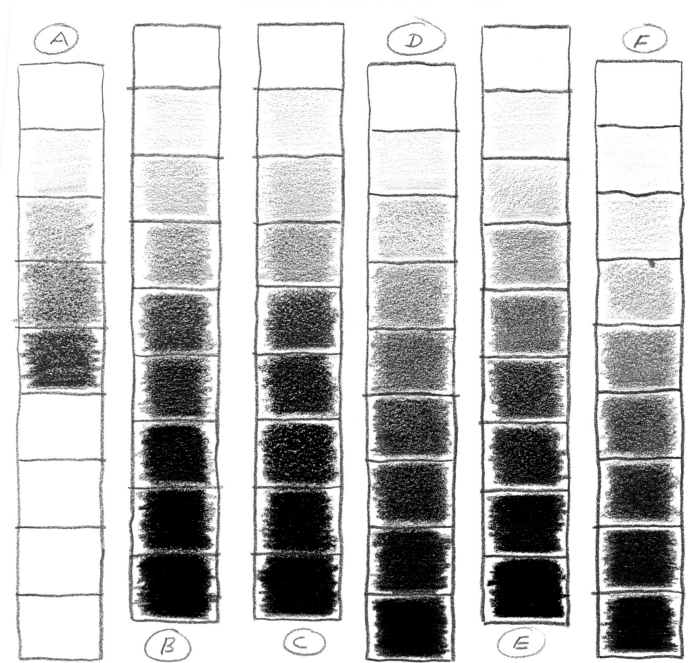

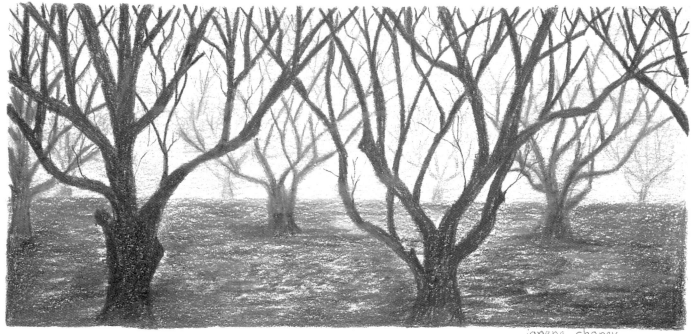

janene chaney

## STUDENT DRAWING
*JANENE CHANEY. COLORED PENCIL ON PAPER.*

In this assignment of expressing mood, this student chose to draw part of a winter morning filbert orchard outside her window. Using low-key values, she convincingly suggested a mood of starkness and loneliness.

Successful as it is, however, in its expression of mood, this drawing contains a problem often seen in low-key color drawing—the problem of a lack of color identity. Dark colors mixed too thoroughly often result in a look of sameness.

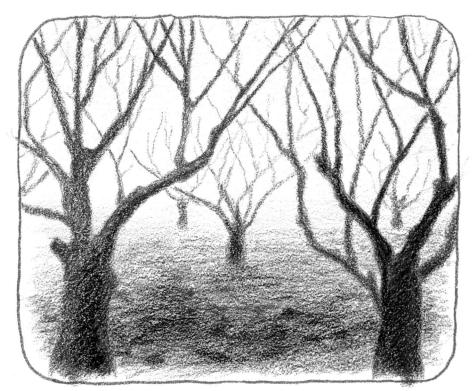

## ACHIEVING COLOR IDENTITY

Here is what I mean by color identity. In this colored pencil version of a part of the orchard scene, colors have been allowed to burst or separate a little more. The overall key remains dark, and the mood is the same, but more intensity of color has been added.

Specifically, after rendering both foreground trees with a 933 Blue Violet as the main dark value, the tree at left was modified with a 931 Purple and a much more intense 922 Scarlet Red. The blue of the tree at right was then mixed with an also more intense 907 Peacock Green.

# 12. MIXING DARK COLORS

Although there are many color drawing media—and the methods for mixing color with them differ somewhat—I think we can group most of the color drawing tools in current use into four major categories. These are the colored pencils (and their stick versions), the soft pastels, the oilier pastels and crayons, and the felt-tipped markers used in combination with colored pencils.

## CONSTRUCTING NEAR-BLACKS WITH COLORED PENCILS

Colored pencils and their stick versions are semi-opaque. With them, colors can be layered to construct rich and colorful near-blacks.

The swatch at A is probably my own all-time favorite for this. It contains 901 Indigo Blue, 937 Tuscan Red, and 931 Purple. It is a versatile near-black and can—depending on the order of color layering—be of either warm or cool temperature. Swatch B, by way of contrast, is 935 Black. Although a nice enough black, it is devoid of hue. Swatch C is 935 Black again, but enriched this time with 907 Peacock Green.

The swatches at D and E were made with the stick versions of colored pencil; they contain a little more wax than the pencils. The colors used for D are 901 Indigo Blue and 931 Purple. Swatch E contains a mixture of 901 Indigo Blue and 947 Burnt Umber.

## DRILLED CARDS

*COLORED PENCIL AND TURPENTINE ON PAPER, 9½" × 13" (24 × 33 cm).*

In this drawing, I wanted a very dark background as a contrast for the playing cards. But I didn't want the background completely uninteresting. After all, that would be a lot of nothing to look at.

To make my dark background area more complex, I began by loosely laying in some colored pencil black, then adding to it passages of blue, yellow, violet and even a bit of orange. This combination of colors was then worked in and liquified with turpentine and a white bristle brush.

COLORED PENCIL          ART STIX

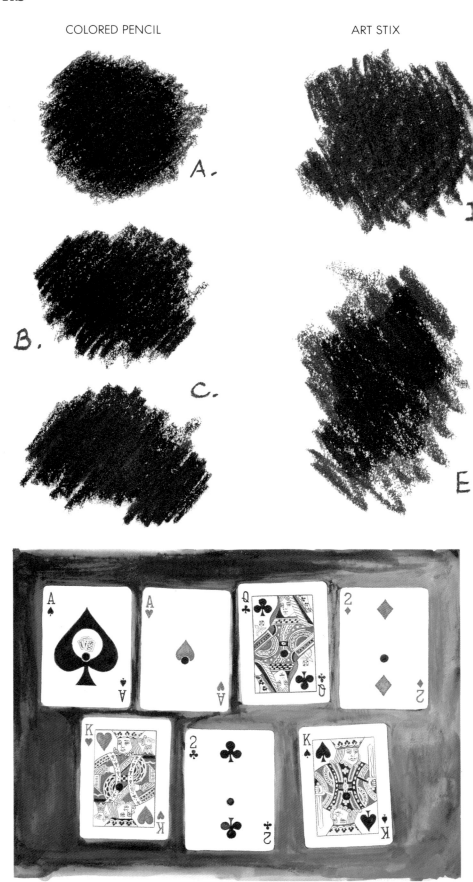

A.

B.

C.

D

E

Near-blacks can be achieved with other color drawing media. For example:

*Soft Pastels* cannot be layered as if transparent. They remain, however, extremely mixable, perhaps because of their powdery nature. Near-blacks can easily be constructed with two or more dark colors, as shown in the first swatch. Blacks can also be enriched by adding other colors to them.

*Oil Pastels or Crayons* do not mix well with heavy pressure. The first example of this, made with Sanford's Cray-Pas, shows a heavily applied second color resulting in a kind of plowing up of the first color. Filia oil crayons are similar, and succeeding heavy strokes with them seem to lift up previous color layers. The little light flecks in the first oil crayon are an example of lifting up the first layer. A better way of gaining

rich blacks with these media is to begin with a loosely applied black, then carefully add hue to it. This was done with the other examples of Cray-Pas and oil pastels.

*Felt-tipped Markers* work well as a base for colored pencils in building near-blacks. In these swatches, medium-dark colored markers were used first, then various pencil colors tonally or linearly added to them.

PASTEL

CRAY—PAS

OIL CRAYONS

FELT-TIPPED MARKER
AND COLORED PENCILS

# 13. HANDLING CAST SHADOWS

In addition to the light and shade that artists use to model form, there are also shadows cast by objects themselves. Often these cast shadows are minimized or eliminated altogether in a drawing because they can distract or confuse the image. At times, however, cast shadows become important or dramatic elements to a composition. In this case, their handling must be done in ways suited to the drawing's composi-tional and color needs, rather than with a standardized treatment or a reliance on "reality."

Here are some ways to handle cast shadows that have been helpful to me:

1. Simplify them. Disregard or combine a multiple of shadows caused by more than one light.

2. Keep them transparent. Darkness does not have to mean opaque. Let surface texture con-tinue to show through the shadow.

3. Soften a cast shadow's edges, unless showing harsh lighting is your aim.

4. Lighten the darkness of shadows as objects recede (and give up sharpness of contrast).

5. Use dark colors rather than a dark neutral to render shadow values. Take notice of the colors of surfaces on which these shadows are cast, and keep in mind the color you feel your composition needs.

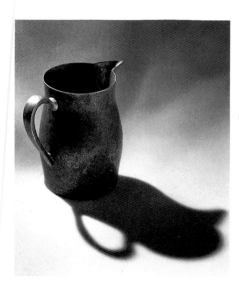

## OBSERVATION

Sometimes the shadow cast by an object becomes an important element in itself. In color drawing, these shadows are better handled with color than with neutrals.

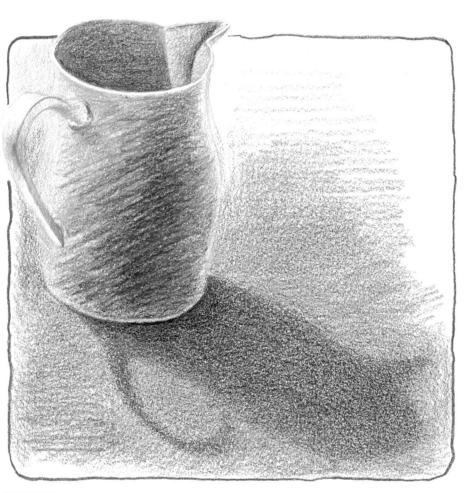

## SKETCH 1

In this sketch, based on the above pitcher and its cast shadow, red and red-orange were used for the surface on which the shadow falls. To cool the dark area, and indicate or symbolize that less light falls on it, I have used a closely adjacent red-violet hue over those predomi-nant in the surface.

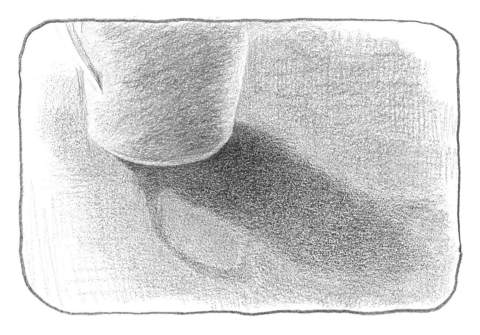

## SKETCH 2

This time, instead of using only the slightly cooler adjacent hue for the shadow's dark area, I have gone all the way to blue-violet.

One of the nice things about colored pencils is how their transparency works also at handling shadows. In this case, for example, the red and red-orange were drawn first, then the blue-violet layered over it. With more opaque color media, the differing colors would have to be juxtaposed—that is, drawn in side by side—to get the feeling of a transparent colored shadow.

## SKETCH 3

All cast shadows drawn in color should be somewhat transparent. But surfaces on which a pattern or distinctive area is to be shown shadowed make transparency even more important.

To keep the cast shadow on this patterned surface from becoming too heavy or opaque, each colored element of the surface was simply rendered in a cooler version of itself in the shadowed area. Pinks, for instance, became in the shadow darker red-violets, while blues became darker blue-greens.

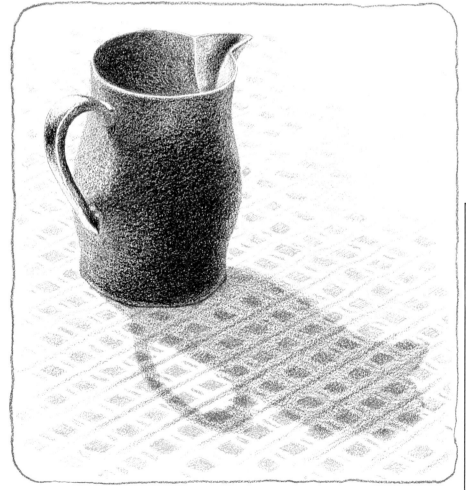

## WORKBOOK ASSIGNMENT

Drawing cast shadows is a good way to break any habit of thinking in dark neutrals—and to think instead about using dark colors.

On a fairly large sheet of paper, rough-in six separate thumbnail sketches of an object which show a cast shadow. Keep them all similar and simple. Change surface and shadow colors in five of them, making sure at least one has a patterned surface.

With the sixth sketch, try a color idea so risky that you are just about sure it won't work—a yellow shadow, for example, or some pattern changes that occur only in shadow. If this one fails, you won't be surprised (you expected it). If it works, the result may be spectacular.

# 14. MAKING ELEMENTS ADVANCE OR RECEDE

Whether we want illusions of depth in our drawings or not, we must still know something about why things seem to advance or recede. The fact is, even absolute flatness of effect is also an illusion—achieved by *not* allowing elements to move forward or backward as they naturally might.

When we talked about using color for structure, we observed that brightness and warmth are compelling signals of spatial position. Other devices available to us—based on real life clues for perception—are:

*Overlapping Elements*—This is one of the most elementary ways of showing one thing behind another, and therefore farther away.

*Relative Size*—We are all familiar with railroad tracks, roads, and even people diminishing in size as they grow distant. Think also of a drawing's surface texture, with larger or smaller marks used as subtle depth clues.

*Pattern*—Patterned background areas come forward much more than plain areas. I frequently use patterns in this way as a device for compressing space.

*Position*—Whether elements are placed high or low in a composition greatly influences our interpretation of where they are in space. An object placed at and connected to the bottom edge of a picture, for example, usually becomes that picture's most forward element.

*Isolated Color*—A patch of color of different character than what is around it will appear to come forward. This is apparently a function of emphasis.

*Brightness and Warmth*—As stated earlier, relative brightness and warmth appear to advance; dullness and coolness to recede.

*Light and Dark Values*—These, curiously enough, can both recede. In real life, distant terrain appears lighter in value than foregrounds, and we often use this natural phenomenon in our drawings. With a still life, however, where vastness of space is not present, values are darkened to show a progression of depth.

*Contrasts*—Many of our assumptions about what we are seeing are based on contrasts. Within a drawn form, sharpness of detail (sharp contrast) suggests nearness. Much the same holds true between a form's outside contour and its surroundings. When contour edges are sharp and crisp, shapes seem to separate and come forward from their backgrounds. When edges are fuzzy, indistinct, or of similar values with their backgrounds (lacking in contrast), shapes appear to merge with their surroundings.

All of these things depend for conviction on context, of course. Usually they appear as combinations, working together toward an overall unity of effect.

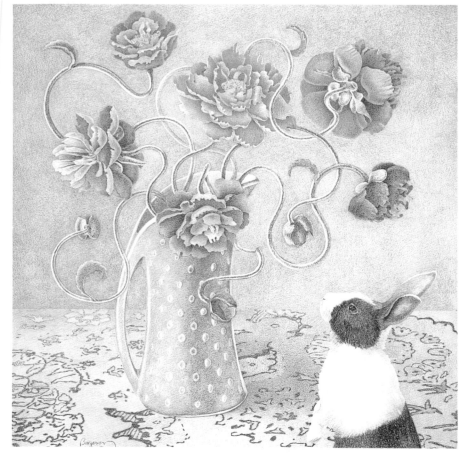

## UNFINISHED DRAWING

I thought this color drawing was finished. But as time passed, I often found myself looking at it with a feeling of disappointment.

During the planning and drawing of it, I had thought I knew exactly how I wanted the different elements to retreat and advance. For the flower stems, I relied on hue changes, as well as changes in value between them and their negative space. The blooms were carefully positioned with variations in warmth and brightness. The rabbit was connected to the bottom front plane, and drawn with a warm red-orange to help bring him forward.

Although all of these devices, and a few others, appeared individually to be doing what they were supposed to, the drawing itself seemed a failure. Overall, it seemed to lack clarity. I finally began to suspect that its negative space was too thin or too weak to serve as the needed foil for this drawing's other elements.

Fortunately, colored pencil is a medium that allows for reworking without harm. I decided to risk the whole thing on a big background change.

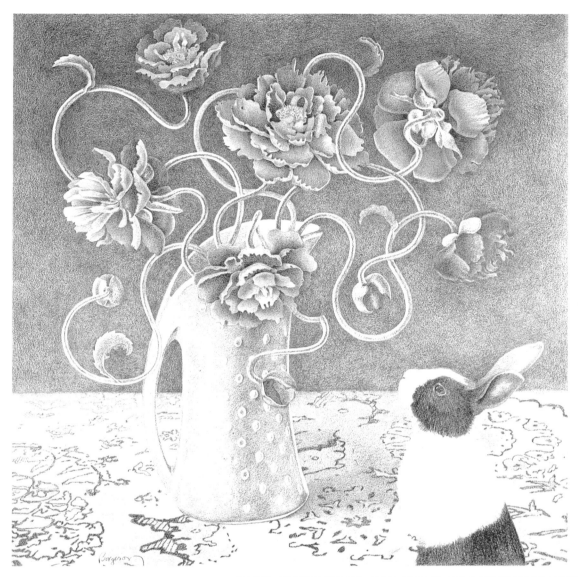

## WILDING

*COLORED PENCIL ON PAPER, 18½" × 19"*
*(50 × 48.2 cm).*

We sometimes forget that color also has weight—what we might call substance. Although this picture's clues to spatial relationships were in place in its first version, they were muffled by a background that was too light in weight (in relation to other elements in the drawing) and too insubstantial.

The only change between this and the first version of this drawing is that the background has been darkened and given a blue hue. It still has some of its transparent atmospheric quality, but the overall effect of increased contrast and clarity now allows all the other depth clues to work better.

## WORKBOOK ASSIGNMENT

If you feel unable to see elements come forward or retreat in drawings, I want you to do a special exercise. You'll need two colored pencils—901 Indigo Blue and 918 Orange (with other drawing media, a dark, dull blue and a bright orange).

First make a circle—about an inch or so across—and fill it in solidly with orange. Use plenty of firmness. Now make a second circle behind the orange circle that is partly hidden from view by the orange. Fill in the visible part of this circle with blue, using a comfortable pressure.

To make your orange circle come forward—which by now it surely does—you have used three depth devices. These are overlapping of edges, warmth of color temperature, and brightness of hue.

Let's remove the overlapping factor. Make two new patches (not circles) with the same two colors, side by side, but not touching. I think you will find that your eye is already more sensitized than it was, and that now you can easily see the orange advance and the blue recede.

# 15. PUSHING COLOR

Up until now we have looked at ways to use color for structure and modeling, and we have been pretty specific about these ways. But "pushing" color cannot be dealt with quite so specifically, for it deals with our intuitive abilities at using color.

The definition for pushing color that I like best is "to emphasize color changes in such a way that a color reaches a kind of peak." A red, for example, which begins as a low and rumbling red, is made to pick up speed until it throws off sparks of orange, violet, and blue as it reaches the height of color. Meanwhile, the local color of the object that is being drawn may still show it as a dull-seeming and stolid red.

Students often ask: why bother with this? Isn't the idea in drawing (representationally, at least) to stay faithful to the local colors of things, to draw what we actually see? The answer to this, I fear, can only be "sometimes," and "maybe," and are we aware of what we really see, or only what we think we see?

Take a bunch of bananas. Try drawing them with "banana colors" and the result will undoubtedly have a look of falseness. It may also look simplistic and boring, and revealing of a lack of personal involvement. What we must do is find in our bananas some kind of "color resonance" as a convincing way of communicating their reality. We must somehow "push" their color.

And how do we do this? What is our strategy here? First of all, I think we must develop a willingness to depart from what we think we are seeing. Pushing color often requires taking some risks, breaking down some barriers.

A second thing we must do is scrutinize—really scrutinize—the true colors of the things we are drawing. What we may first see is a red. By slowing our gaze and peering, we will get other color "hits"—nuances of color from reflections or subtle changes in light. These are what we will emphasize.

Finally, we must combine our color scrutiny with our own attitudes about the subject. What color change, for example, might make a red seen more tart, a green more soft? Local color may or may not contain enough information for your color choices. Some of the motive for this may lie in your own attitudes or memory. Reality will be merely our departure point.

As you look at the drawing and its close detail on these pages, and begin the drawing assignment on the following page, remember that how you push color will always be up to you. But keep an eye too on selectivity. The needs of our overall compositions also have to be reckoned with. Even pushed colors can lose effectiveness if there are too many of them, and all are competing with one another.

UNDERSTUDY

COLORED PENCIL ON PAPER, 6½" × 8½" (16.5 × 21.6 cm).

My idea about this little drawing was to present a bit player as if in a leading role. Flowers are usually shown head-on and facing front. They are in fact interesting from all angles, including their undersides.

To help suggest that there may also be some surprises in this view of a flower, I pushed what would ordinarily be a darkening of color to a change in color—from red-orange to blue-violet. Although it was quite a long way from the reality of local color, it focuses more attention on this area of this flower.

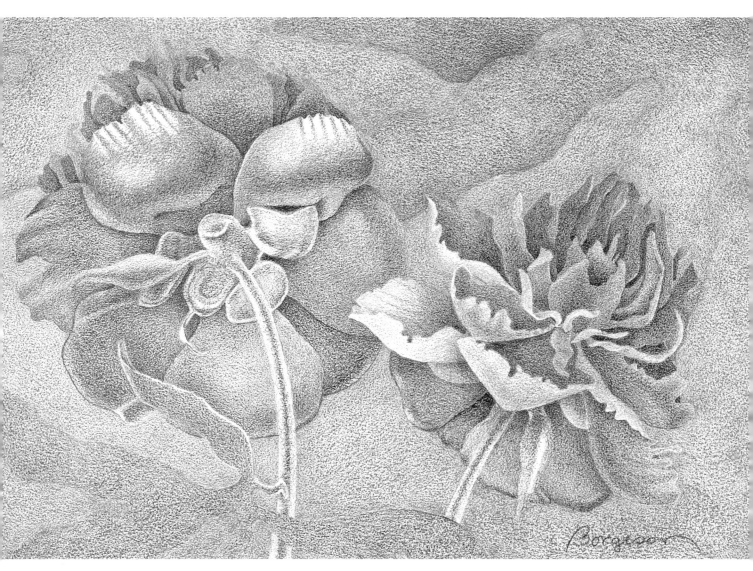

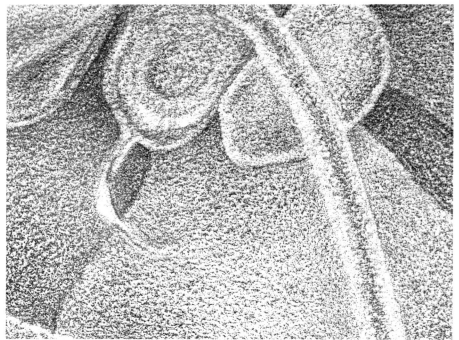

## DETAIL

I rarely feel brave enough to just plop a new color down in the midst of others. As you can see in this magnified detail, the blue begins within intermediate mixtures. It is layered at first with dominating reds and oranges, and only gradually becomes the dominant color itself.

This does not mean that a more abrupt color change would be wrong. It is part of my own handling of color to make changes slowly but emphatically. You may prefer faster, more vigorous color changes; it is choices such as this that will make your color handling distinctive and yours alone.

# PUSHING COLOR

## DRAWING ASSIGNMENT

Pushing color will help you handle color in more personal and expressive ways. Here is how you can prove this for yourself.

1. Begin by selecting a familiar object to draw from life. Pick something with a well-known color, something like yellow bananas, a red tomato, black binoculars, green ferns, a terracotta pot, an orange or tangerine.

2. Use any color drawing medium you like, but plan to have your subject large on the paper so you can really concentrate on it. Block-in light guidelines with graphite if you want to.

3. Now, instead of reaching for the color you know your subject to be, hold off. If you chose a tomato, for instance, don't reach for red. Instead, take a long slow look at your subject. Is it reflecting any color from the surface it is sitting on? From any other objects nearby? Take your time with this. If it is a tomato, it may be a trifle unripe and slightly green, or too ripe and shifting toward gray. Look for even the smallest hints of color other than your subject's "normal" color. Check also on your own feelings. What kind of color might suggest your own attitude about this subject?

4. Begin drawing with colors from whatever hints or clues you have been able to gather. Use none of your subject's local color. As your drawing nears completion, stop again.

5. This is the time for considering local color. By this time you may feel a strong need to use some of it. Or you may feel no need at all. Should you opt for the first route, go slowly. Use it in just a few places at first. You may be surprised at how little local color is really needed. A still greater surprise, however, may be your discovery that reality can sometimes be well shown with no local color at all—and that your drawing can now be finished without it.

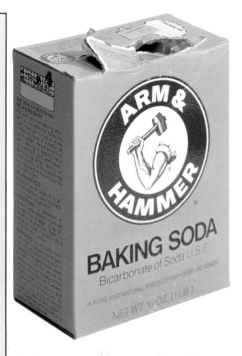

## OBSERVATION

A baking soda box makes a good subject for pushing color. We recognize its color and shape immediately. And like many such things, it can, if we are not careful, persuade us that we hardly need glance at it to draw it—that we already know all about it.

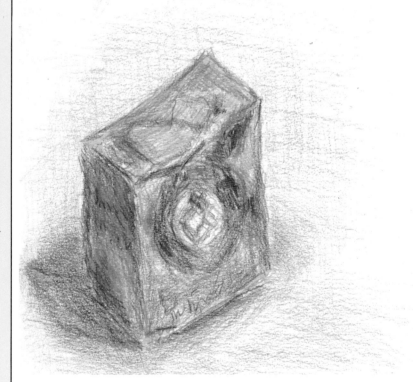

## STUDENT DRAWING
*LARRY BEGLEY. COLORED PENCIL ON PAPER*

Here is one example of pushed color using the above baking soda box as a subject. Beginning with colors other than the box's own yellow-orange local color—including red, green, and violet—this student did not turn to yellow-orange until the drawing was almost finished. And even then, the local color was used only sparsely. This has resulted in a very personal and distinctive rendering of a very commonplace subject. Notice also how the box's cast shadow has been handled in a similar spirit.

# 16. MIXING ANALOGOUS COLORS

Mixtures of analogous colors are extremely useful to me. I use them for achieving brilliance when I feel that a single intense color would produce too raw or strident an effect. Mixing two closely related colors usually suggests to me a more refined brilliance.

## ANALOGOUS COLORS

Analogous colors are those similar in hue, and neighboring on a color wheel. They are related as groupings of color, but not rigidly so. Color wheel A, for example, shows orange as analogous with red-orange and yellow-orange, while color wheel B shows orange as analogous with red and yellow. The analogous group in color wheel C includes all the oranges and all the reds.

The only important limitation to analogous mixtures is that of temperature. In general, colors do not effectively remain analogous if opposed as warm and cool.

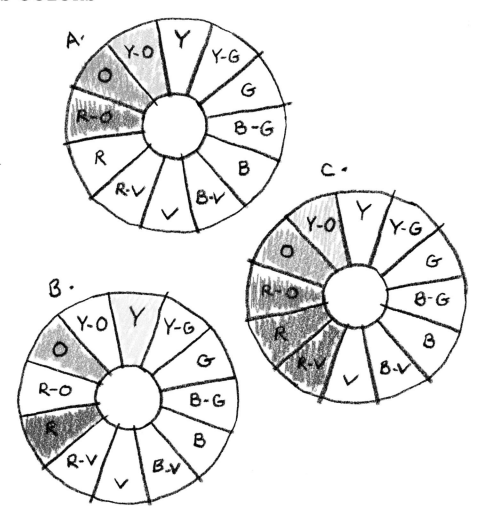

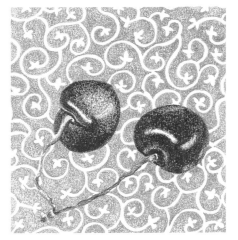
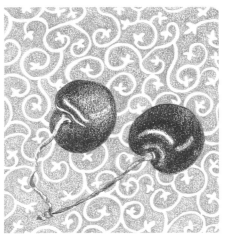

## TWO STUDIES USING ANALOGOUS COLORS

Besides using analogous groups of hues for color mixtures, we can also use them as overall color schemes. The color schemes for both these little studies use analogous relationships. In the one at left, red and red-orange were used for the cherries, and red-violet for the pattern. The other also uses red and red-orange for the cherries, but this time with a yellow-orange for its pattern.

## WORKBOOK ASSIGNMENT

The effects of mixing analogous colors can differ slightly depending on how thoroughly the colors are mixed. Loose combinations often tend to produce richer results than those mixed more tightly. In the combination of blues and pinks shown, the looser blends can also be seen to resemble their original colors more than new intermediate hues. The small examples of analogous mixtures show how you can brighten a color's intensity by adding just a little of a brighter analogous color to it.

A drawing's special quality can be greatly enhanced by mixing similar colors together to communicate brightness in a kind of "soft sell" way. Take the time to mix some analogous colors in your own workbook. Use the combinations shown here as a guide if you like, but try a few mixtures of your own as well.

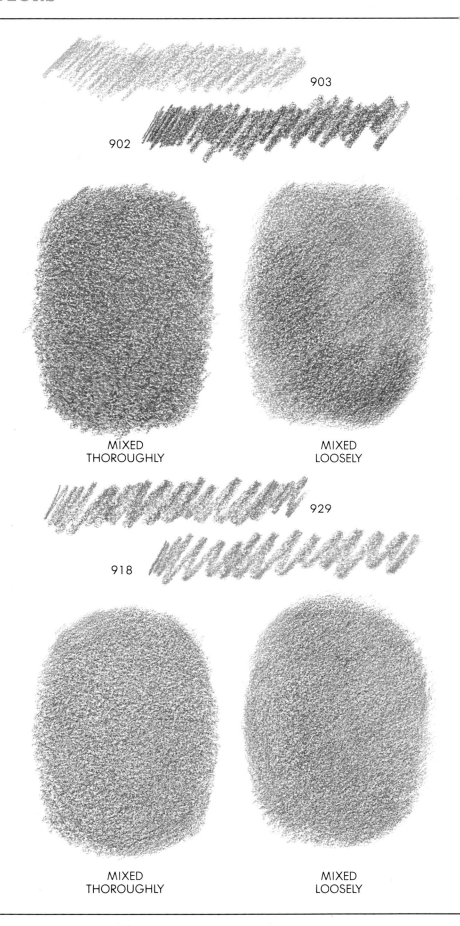

903

902

MIXED THOROUGHLY

MIXED LOOSELY

929

918

MIXED THOROUGHLY

MIXED LOOSELY

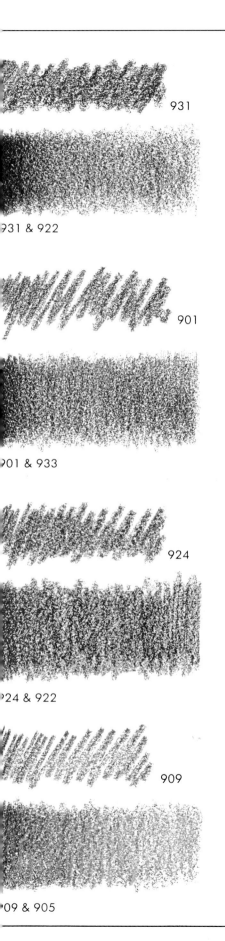

931

931 & 922

901

901 & 933

924

924 & 922

909

909 & 905

## STUDENT DRAWING

*CYNDY HEISLER. COLORED PENCIL AND COLORLESS BLENDER ON PAPER*

The dominant colors in this drawing are analogous—blue-green, blue, blue-violet. Notice, however, that this student has also used a second set of analogous colors (yellow, yellow-orange, orange and red-orange) as accents.

These bits of minor color, all complementary to the dominant colors, are essential to the picture's effect. Imagine the unrelieved sameness the drawing might have without them.

# 17. MIXING NEAR-COMPLEMENTARY COLORS

Mixing complementary hues—direct opposites on a color wheel—is supposed to lead to neutral gray. But in real life, where we deal with a vast and wild assortment of colors (rather than just those of a color wheel's tidy twelve) finding exact complementary pairs is pretty difficult. What we can more likely expect to find are near-complementary pairs, which yield near-grays.

For me, this is a happy situation. I think it is among these near-complementary mixtures that we find our most sophisticated and tempered colors. They are the colors of no stridency and of softly shifting hues.

## WORKBOOK ASSIGNMENT

Here are four mixtures of color that seem to fall "between the cracks" of our regular color wheel. They are colors we don't have ready names for. But because they are made of near-complementary hues, and are therefore dulled, they serve as excellent foils for unmixed colors. Notice how bright the original colors (in the centers) look in comparison with their surrounding mixtures.

Mix some near-complementary colors in your workbook. Remember that amounts and proportions of color—important in mixing paint—often translate in drawing to pressure of application. In illustration D, for example, three wedges look greener than others. This is because the green was applied with more pressure. Here are the pencils I used:

A. 924 Crimson Red, tonally applied over: (clockwise from top) 919 Non-Photo Blue, 910 True Green, 903 True Blue, 909 Grass Green, 905 Aquamarine, 907 Peacock Green.

B. 931 Purple over: 942 Yellow Ochre, 910 True Green, 912 Apple Green, 909 Grass Green, 913 Green Bice, 907 Peacock Green.

C. 903 True Blue over: 947 Burnt Umber, 922 Scarlet Red, 937 Tuscan Red, 918 Orange, 943 Burnt Ochre, 942 Yellow Ochre.

D. 913 Green Bice over: 929 Pink, 924 Crimson Red, 956 Light Violet, 932 Violet, 930 Magenta, 931 Purple.

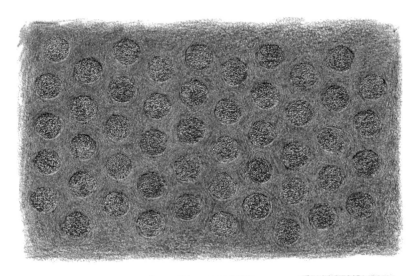

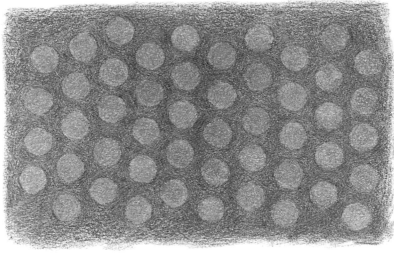

## HUE CONTRASTS

A frequent pitfall awaiting us when we begin drawing with color media is an over-reliance on value contrasts. Our experience with black-and-white drawing does not prepare us for the potentials of hue contrasts.

What we seem to most easily remember about complementary and near-complementary colors is that this relates to their positions opposite one another on a color wheel. More important for our purposes is that these are the colors opposite or near-opposite in hue. *They are contrasting hues.*

In this near-complementary color scheme of a green field with red-orange dots, for example, a juxtaposition of intense hue differences sets up a sensation of visual vibration. Compare this with the black and white photograph, which shows that our contrast is almost entirely of hue, and that there is very little contrast of value.

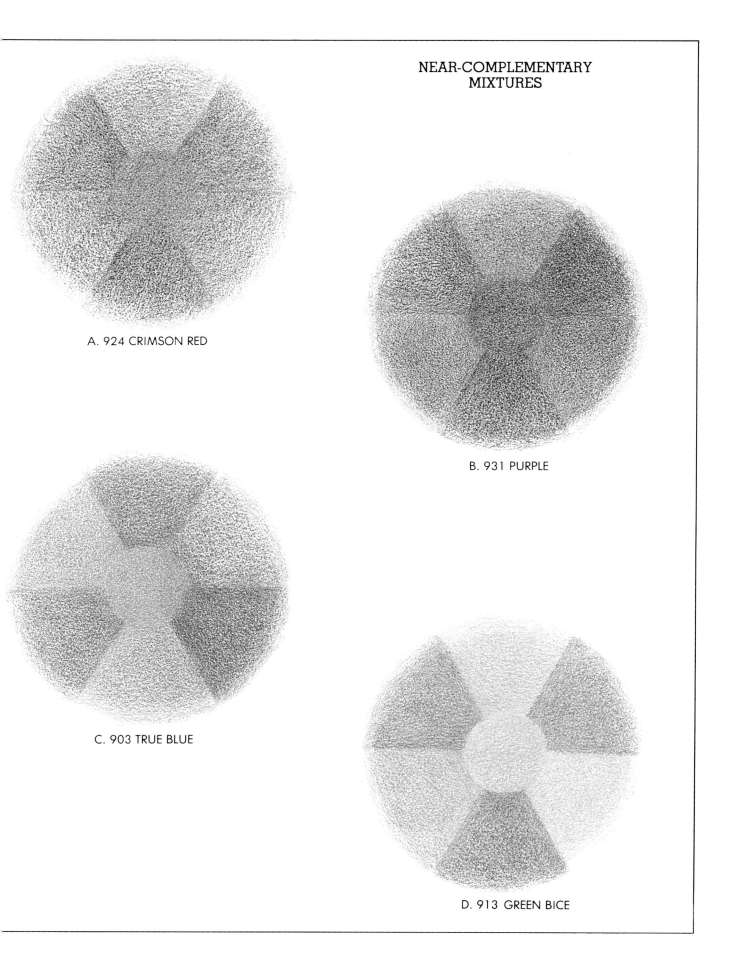

## NEAR-COMPLEMENTARY MIXTURES

A. 924 CRIMSON RED

B. 931 PURPLE

C. 903 TRUE BLUE

D. 913 GREEN BICE

# MIXING NEAR-COMPLEMENTARY COLORS

## JAPONAISE
*COLORED PENCIL ON PAPER, 16" × 20", (40.6 × 50.8 cm).*

In this drawing, I used near-complementary mixes to develop the leaves. It is this mixing strategy that often yields more natural-looking greens.

Almost all the muted colors found in nature, in fact—earth, rocks, tree bark, and foliage of all kinds—can probably be most accurately rendered with near-complementary blends of color.

## NEAR-COMPLEMENTARY MIXTURES

Here are two greens I frequently use, both mixed from near-complementary colors. The more mellow mixture at top begins with a lightly applied layer of red (924 Crimson Red). A warm Green (911 Olive Green) is then added. The cooler green under it, suggesting shade, is an initial layer of red-violet (931 Purple), overlaid with green (909 Grass Green).

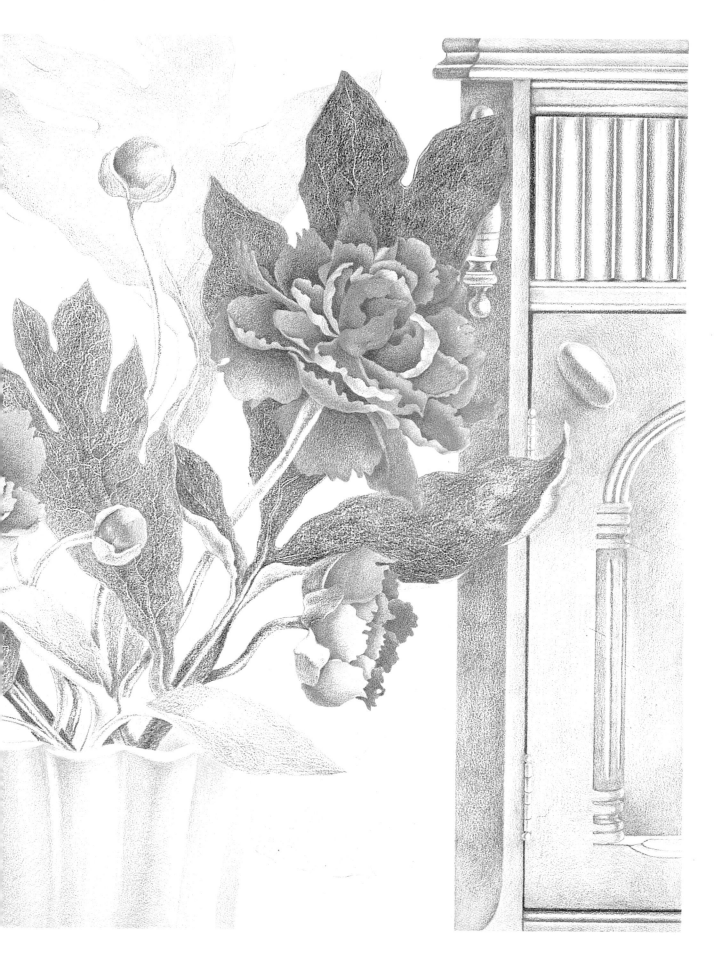

# 18. MIXING GRAYS

When using dry drawing media, mixing neutral grays from two complementary hues can be a difficult job. I prefer to use pencil grays when an exact neutral is needed. These are readily available in warm and cool, as well as light, medium, and dark grays, and some contain slight suggestions of hue.

## STUDENT DRAWING
*S. GAYLE FLEMING. COLORED PENCIL ON PAPER.*

At first glance, the negative space of this drawing appears to be of a single gray. Notice the difference however, between the area at top left and that at bottom right. To produce this modulated gray—one with some feeling of hue in it—this student began with 963 Warm Gray Light as a base, then worked into it combinations of 936 Slate Gray, 903 True Blue, and 904 Light Blue.

## GRAY SWATCHES

With light values, it is especially difficult to arrive at a predictable neutral by mixing two complementary colors. The sample mixture F was made in this way, from a 924 Crimson Red and a 907 Peacock Green. It is a nice warm gray with hints of green and red in it. But mixing a lighter valued version of it is not easy, and even this one is hard to control.

It is much more efficient for this kind of neutral to begin with a gray, and modify it. Sample A was made with 967 Cold Gray Light with a little 956 Light Violet added to it, and B is a 968 Cold Gray Very Light with 905 Aquamarine. Sample C and D are unmodified warm grays—962 Warm Gray Medium and 964 Warm Gray Very Light—and E is an unmodified 936 Slate Gray, which already contains a blue hue.

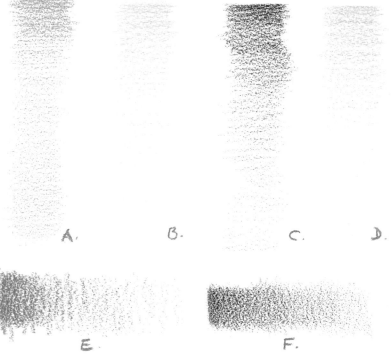

# 19. MIXING FLESH COLORS

Manufacturers of artists' paints and color drawing media almost always offer a color called "flesh." The problem with it—and the reason many artists tend to scorn its use—is that it suggests a single solution to all "flesh color" needs. This is of course not possible, as there are as many local colors for flesh as there are for any other generic thing in our real world. And these skin tones must be further modified for needs of composition, color schemes, and lighting conditions.

## STUDENT DRAWING
*LARRY BEGLEY. COLORED PENCIL ON PAPER.*

In this self-portrait, flesh has been rendered by using no flesh colors at all. What this student has done instead is to use a combination of loose and sketchy lines of near-complementary hues. These combine with the white of the paper to evoke a suggestion of warm and cool flesh colors.

## FLESH COLOR SWATCHES

A workable strategy for using a ready-made flesh color with any color drawing media is the addition of other colors to it, depending on need. The color at left is 939 Flesh. I have added a little green and blue to it, to suggest a shaded version. The center color is a mixture of two colors: a 942 Yellow Ochre, with a 922 Scarlet Red over it. I often use this as my basic "Anglo-Saxon" fleshtone, but always modulate it with still more color, as in the example at right.

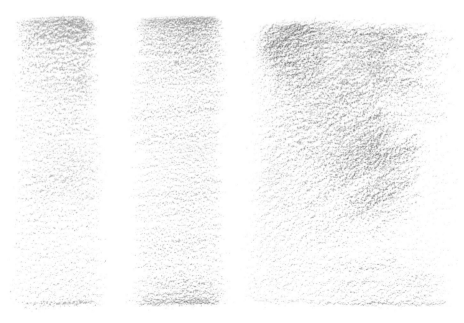

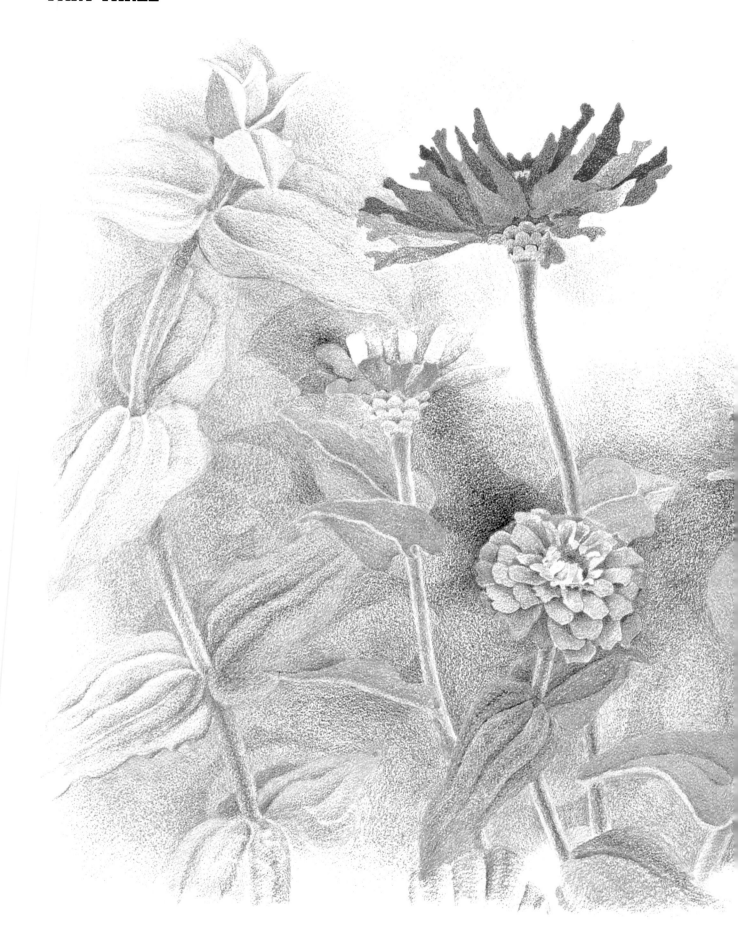

# HANDLING SURFACE AND TEXTURE

This group of lessons puts some of our earlier concepts and observations to work at specific tasks. We will handle such varied surfaces as glazed and unglazed clay, glass, foliage, drapery, metal, and hue-laden whites. We will look also at how less tangible space and atmosphere can be conceived and drawn—the flare of emanating light as well as various ambient textures—and will offer some suggestions for handling compositional empty spaces with color and textural changes.

## 20. EMANATING LIGHT

Light sources can have a glowing effect. It is this emanating quality of light that we often see in such things as neon tubing, table lamps, candles, and night lit windows. Expressions of emanating light can be powerful compositional elements in our drawings, as well as compelling signals of mood.

### SOME OBSERVATIONS

To begin my little drawing of birthday candles on a cake, I set up a pair of candles for a firsthand look at how candle flames actually emanate light. In this photograph of my setup, the scene looks slightly darker than it actually was, and the flames are flaring a little less than they really were. But it still shows how the flame edges fuzz most where the light is strongest. And this suggests—for drawing emanating light—that a weak flame's (or light bulb's) edge is likely to be sharper than the edge of a light with more strength.

Another thing this setup shows is how fast illumination fades when it comes from a weak light source. The tops of both candles look much lighter than their lower shafts. And the area beneath the shorter candle is more illuminated than that beneath the taller candle, which has a slightly more distant flame.

Notice also the peculiar pattern of opposing cast shadows that the candles give one another, and the manner in which the flames surround their wicks. These are all characteristics we instantly recognize as true when seen in real life, but which are difficult to recall when drawing from memory alone. See what else you can determine about the ways that candles burn, including what gives the top of a burning candle its characteristically liquid look.

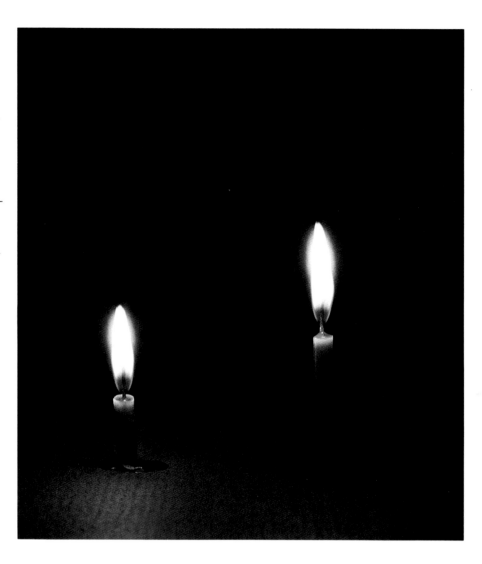

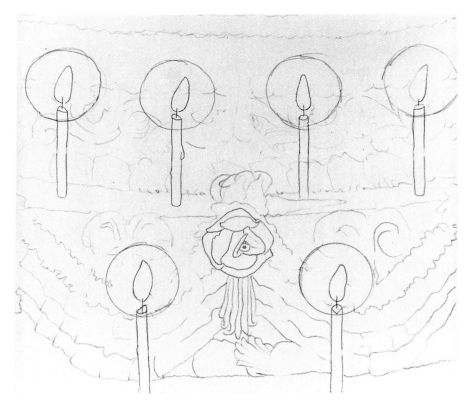

## STEP 1

When working with colored pencils, I like to first lightly lay in my composition with an HB graphite drawing pencil. With colored pencils, preliminary lines are difficult to erase away.

On a sheet of two-ply, 100 percent rag Strathmore paper with a medium-grain surface, I laid in a fairly close view of a section of cake with six candles. I drew circles around the flames to indicate areas that will be flared. These could have been oblong rather than circular shapes, but I wanted to repeat the curling forms of the cake's decoration. The circles are also of about the size of the center rosette. All this preliminary graphite work will be erased as I begin drawing with color.

## STEP 2

In this second step, my purpose was to clarify the drawing. Using a 922 Scarlet Red, I drew a frame of reference around the composition. With a 929 Pink, I began to establish the stepped quality of a tiered cake by indicating plane changes with changes in value. There are now two slightly darkened vertical walls of the cake and two lighter flat surfaces.

This pink was also used to establish raised forms of the cake's decoration, but not with much development at this point. The graphite guidelines have been erased, except for fragments near the candles. Notice that while the halolike flares remain relatively unchanged, a little of the pink is now inside them as a start at suggesting forms in those areas too.

# EMANATING LIGHT

## STEP 3

Some of our observations about real candles can now be put to use. All were drawn with 903 True Blue, 905 Aquamarine, and 932 Violet. The use of three colors allows for individual variations among them. In each, the wick is the same color as the shaft, except where it enters the flame—and becomes near-black (901 Indigo Blue and 931 Purple). Notice the tiny highlights beneath the wicks. These are what make the wax look liquid.

At this stage, the candle at top left is pretty well developed. The next three candles show this as a progression. First (second candle from top left), the blue gaseous area was drawn with 903 True Blue and 902 Ultramarine Blue. Next (third candle), the hot area was drawn with 939 Flesh over the blue center and on up the side of the flame to its top. In the center of the flame, I used a 916 Canary Yellow, letting it move out into the flare to warm the paper. Finally (candle at far right), I used a kneaded eraser to lift out some of the color and to soften the flame's edge.

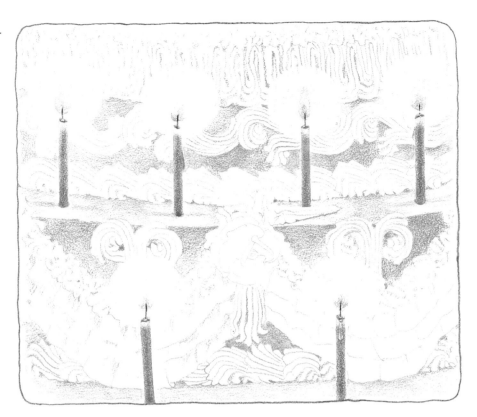

## STEP 4

More of the cake's bottom tier was developed by overlaying the 929 Pink with a combination of 922 Scarlet Red, 932 Violet, and 931 Purple. Where the planes change (near the drawing's center), the 922 Scarlet Red was used most. The 932 Violet was used in the darkest areas.

Compare the flaring of the lower candles now with the undeveloped flaring of those at the top. The halo effects of the background behind them has been drawn in. The amount of such background detail is an important clue to how much transparency—and how much flare—we are looking at. This is a matter of personal judgment and aesthetic intent.

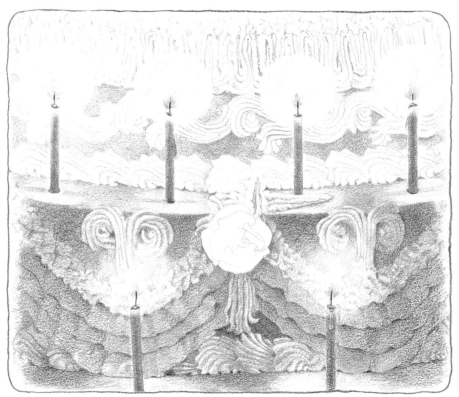

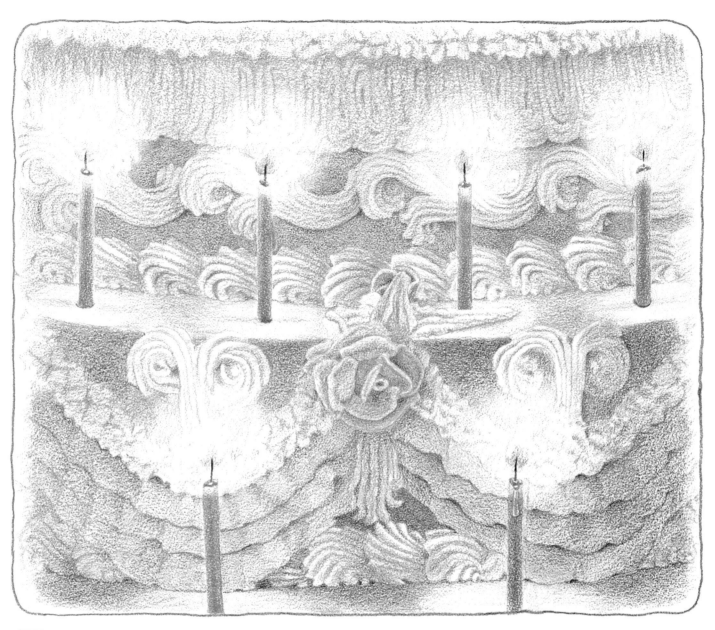

## STEP 5

I completed the cake's upper tier and its center rosette. For drawing the frosting, I used a cooler version of the cake's colors—929 Pink and 931 Purple—adding 916 Canary Yellow to some of the decorations. For the rosette, I used a 922 Scarlet Red and a 916 Canary Yellow. Finally, after looking again at the candle flares, I took them down a bit more by further darkening the areas behind them.

# 21. BLANK WALLS AND EMPTY SPACES

At times we will discover, as we start working up an idea, that our drawing will contain large areas of blank space. These may be part of our "found" scene, or important to a compositional concept. In either case, these spaces become important elements that must be dealt with.

When we choose not to leave large blank spaces blank (unless deliberately very blank), we can generally handle them in one of two ways: we can use color changes, or we can use textural variations. Whichever method we choose, however, if our drawing is to succeed, it must not be a choice made by whim or by habit; it must be a choice based on specific purpose or attitude.

## COLOR CHANGES

To begin a drawing, I usually make a few thumbnail sketches for working out color ideas, and to see if my overall concept looks credible. For example, if this thumbnail were a preliminary idea for a somewhat stark drawing, I would see already that these blank walls of yellow-green local color are a very large element with very little interest.

Although I would want an empty look or feeling, I wouldn't want this area to be boring either. Adding things like wallpaper or doorways would mean more new elements and consequently less of the original notion of starkness. A textural change would likely add too much action or energy for the mood I was after. So, after some deliberation, I've decided that this would be a good time for trying a color change.

In my next thumbnail, the wall at left has been cooled with some blue and another, cooler green. The adjoining wall has been warmed with yellow-orange, and also orange color suggesting reflection from the floor.

Even at this thumbnail stage, the blank spaces begin to take on more complexity and interest. Yet the room still seems to me to read as green, and my idea of starkness still seems viable. I can judge better now—with these hue changes—whether or not I have possibilities here for a drawing.

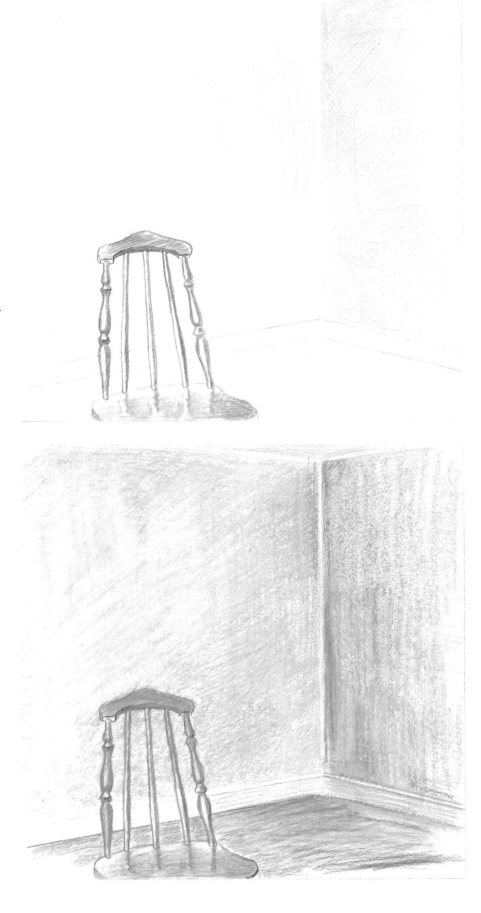

## NAIVE SOLDIERS

*ART STIX AND COLORED PENCILS ON PAPER,*
*9¹/₂" × 9¹/₂" (24 × 24 cm).*

In my drawing of these home cast lead soldiers, I felt it was important to present them as a small, tightly clustered unit. This effect was helped by leaving quite a lot of empty negative space around them.

To deal with all the empty space, and at the same time keep it from competing with my subject, I stressed changes in texture over changes in hue. This gives the space some interest of its own, but still without drawing too much attention to itself.

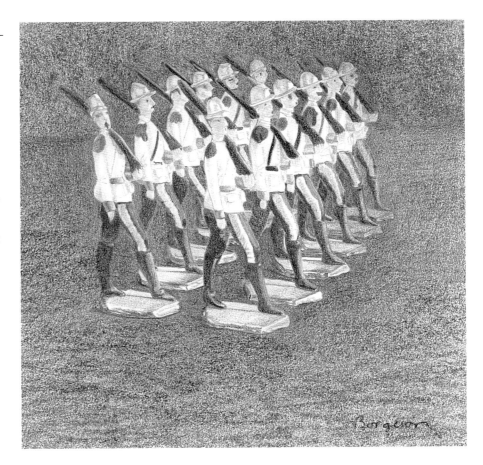

## DETAIL

A magnified view of negative space beneath the soldiers' feet shows strokes of Art Stix loosely applied along with colored pencil. For this kind of work, keeping the pencil points a bit blunt helps in exploiting the paper's own texture; using more than one tonal layer emphasizes the texture still more.

## 22. CLAY SURFACES

For artists, there are basically only two kinds of clay surfaces—glazed and unglazed. Glazed clay is highly reflective; unglazed is not. With most color drawing media, handling these two kinds of surfaces becomes a matter of handling contrasts between light and dark values. But with colored pencils, there is an additional way of suggesting a glazed surface—with a technique called burnishing.

### GLAZED CLAY SURFACE: STEP 1

As a first step in drawing this glazed ceramic surface, I established the form with color. For the jar's outside, I used a 901 Indigo Blue. For its inside, I continued with the blue, then added some 937 Tuscan Red. (To suggest a background, I also used 931 Purple and 937 Tuscan Red.)

Because burnishing only alters the surface of a drawing—and does not change its value relationships—value changes must be established before burnishing begins. As you can see, this step ends with the jar's form pretty well developed.

### STEP 2

The jar's whole surface was then burnished, using a 938 White colored pencil. The idea here is to press hard with the white pencil, using a circular motion. As the previously applied 901 Indigo Blue is compressed, the tooth of the paper becomes obliterated.

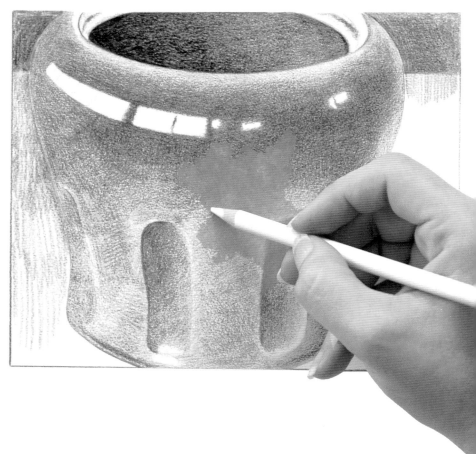

## STEP 3

As a final step, I used a soft cloth to gently rub the surface, smoothing away any ridges. Compare the jar's surface now with its unburnished interior. Notice, too, that the light and dark values of the burnished surface remain as they were before burnishing. The only additional drawing I did after the burnishing was a little laying in of some 905 Aquamarine at the jar's center to better suggest its roundness.

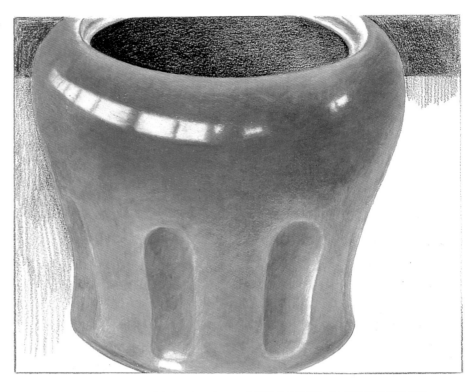

## UNGLAZED CLAY SURFACE

The essential difference between drawing glazed and unglazed ceramic surface lies in the handling of their reflectivities. The surface of the clay nursery pot in this drawing has neither highlights nor reflections. And its value changes are very slow and gradual. Compare it with the glazed jar, in which the snappy reflections of my studio windows are very apparent.

Another characteristic of unglazed clay is a low intensity of hue. No matter what color, unglazed clay is almost always of dull intensity. Which does not, of course, mean a lesser amount of hue. In this drawing, many warm and cool colors were used to suggest the pot's earthen nature.

# 23. GLASS

A key to drawing most kinds of glass is not to draw it at all. Draw what the glass contains, if it is a container; or what lies behind it, if it is a transparent surface such as a window.

For a daylight scene beyond a window, the value contrast is generally kept at a somewhat higher key than the room inside the window. Sharp, bright highlights offer another clue to glass surfaces. But the greatest clue of all is context.

When drawing tinted glass, it is important not to use white when mixing its lighter colors. White added to glass—except for a few small highlights—makes it look as if it's ceramic. It is better to use the paper as a lightest value, then add color very lightly to indicate a tint for the glass.

## CUPBOARD JARS

COLORED PENCIL ON PAPER, 8½" × 8½" (21.6 × 21.6 cm). COLLECTION JAMES AND LESLIE CULBERTSON, JR., PORTLAND, OREGON.

The shapes of these glass jars are mostly defined by the drawing of their contents.

## PIMIENTOS

*COLORED PENCIL ON COLORED PAPER, 4¹/₂" × 5¹/₂" (11.4 × 14 cm). PRIVATE COLLECTION.*

Try drawing a small jar of this kind.

## TARRAGON VINEGAR

*COLORED PENCIL AND PASTEL ON COLORED PAPER, 6¹/₂" × 11" (16.5 × 27.9 cm). PRIVATE COLLECTION.*

This drawing contains a few highlights—made with a light-valued pastel—on the bottle's surface. One of these is just below its cap, and three more are on its shoulder.

But there is also another kind of highlight here—almost an emanating light—in the bottle's interior. This phenomenon happens when light strikes the back of a bottle's paper label. It is often apparent when a clear glass bottle contains a label, and can be an excellent drawing clue to "bottle-ness."

## DRAWING ASSIGNMENT

Make a drawing of glass by "posing" one or two condiment jars—and first dealing only with their contents. Select jars containing things like stuffed olives and pickled garlic bulbs—things interesting enough to keep your attention away from the glass containing them.

When you have drawn these contents in their observed shapes and configurations, you will find that the glass has practically drawn itself. You will then be able to finish the glass form with only the barest of observed details—probably at its top, shoulders, and bottom.

## 24. HANDLING WHITES

To draw white elements convincingly, we must be willing to push color. This is true with semi-transparent as well as opaque color drawing media. Near-whites are similar in their uses to near-blacks in the sense that what reads as white often depends on context.

To draw these peaches on a white linen runner, I have used several colors to *construct* a rich white for the linen that is not stiff or flat.

### STEP 1

The dark table top, which establishes a context for the white linen, was drawn by layering with three colored pencils—901 Indigo Blue, 937 Tuscan Red, and 931 Purple. At the back, only the blue was used. The linen can now be seen emerging from the negative space as white paper. The lower left peach was drawn with 904 Light Blue and 932 Violet for its fuzzed contour edge. Its skin was drawn with 931 Purple, 924 Crimson Red, 929 Pink, and 916 Canary Yellow. I also used these colors as beginnings for the other peaches.

### STEP 2

For the cast shadows of the peaches, I used 903 True Blue and 932 Violet, with more violet in the forward shadow. I then began drawing some very light tints into the white of the linen, using 929 Pink, 913 Green Bice, 918 Orange, 903 True Blue, and 932 Violet. I futher lightened these with a plastic eraser. These tints occupy areas that are to read as "pure" white, as well as areas that are to read somewhat darker. Because the negative space is very dark, quite a lot of color can be added before these whites lose their "whiteness."

## STEP 3: PEACHES AND LINEN.

*COLORED PENCIL ON PAPER, 8½" × 8¾" (21.6 × 22 cm).*

To finish the peaches, I continued with the colors of the first peach, varying hue proportions to avoid a look of too much similarity. Using the side of a pencil lead rather than its point lets the paper texture itself help to fashion peach skins.

I lightened some of the dark negative space with a 938 White pencil, and darkened the linen a bit more with a very lightly applied combination of 932 Violet and 908 Dark Green. Small areas of paper were left untouched in a few places to suggest raised areas within the linen. Some of these can be seen at the linen's edges.

## DETAIL

Notice in the close-up just below the lower right peach how many light tints of color were used in this white—which nonetheless reads as white.

# 25. FOLIAGE

Foliage is often drawn swiftly and convincingly, yet with far less detail than it might seem to require. This comes from a knowledge about what we are drawing.

I think we draw best what we understand best. With foliage, this means observing it first from life, then making notations about key parts of a leaf in our workbooks. The following is a way of doing this that works well for me:

## SKETCHING AND TAKING NOTES

I try to make sketches and written notes—such as these about a geranium leaf—that will continue to be meaningful to me. I generally look for these five clues (things probably more important to an artist than to a botanist) to give me the important characteristics of a particular type of leaf:

1. Shape (thin, succulent, rounded, spearlike, lobed)
2. Edges (scalloped, serrated, smooth)
3. Veins (light, dark, invisible)
4. Surface (matte, glossy, fuzzy)
5. Overall gesture (how it stands, slumps, hangs)

Notes of this kind aren't difficult to make, and you will find that it often takes only one or two of these characteristics to give your drawn foliage a remarkable amount of credibility.

GERANIUM

LEAVES GENERALLY ROUND WITH ONE CLEFT. MATTE. EDGES SCALLOPED →

LOWER LOBE DARKER

STEMS FUZZY

VEINS ARE VERY LIGHT.

EDGE HAS HIGHLIGHT. TRY IMPRESSED LINE.

FROM DOTTED LINE OUT TO LENGTH OF ARROW LEAF HAS DARK AREA BLENDING OUTWARD. 911—GEN'L BODY HUE W/ 901 FOR DARKS. YOUNGER LEAVES HAVE LESS DARK. STEMS + UNDERSIDES LIGHT GREEN — MAYBE 912.

## SOME OBSERVATIONS

Each of these three leaves, no less than our geranium leaf, also has its own individual and characteristic shape. Other differences among them include the light veins of the peony at left, the serrated edges of the rose at center, and the glossiness of the camellia at right. To draw such leaves convincingly, we must somehow suggest their characteristics and differences.

## STEP 1

To quickly sketch these three leaves, I began with some very light shapes, using an HB graphite pencil and a sheet of medium-grained paper. The rose leaf (now placed at bottom left) has a serrated edge, in contrast with the smooth edge of the peony leaf (top). The camellia leaf (bottom right) also has a slightly serrated edge, but because the leaf is thick its edge characteristic is less pronounced.

To indicate the light-valued and delicate veins of the peony leaf, I impressed some of these into the paper surface by drawing them firmly over tracing paper. After taking away the tracing paper, I used a 932 Violet pencil, applying it tonally but so lightly that the impressed lines are not yet very visible.

The dull green of the rose leaf was begun with a 924 Crimson Red, and for the camellia I began with a 913 Green Bice. For the negative space I used 905 Aquamarine.

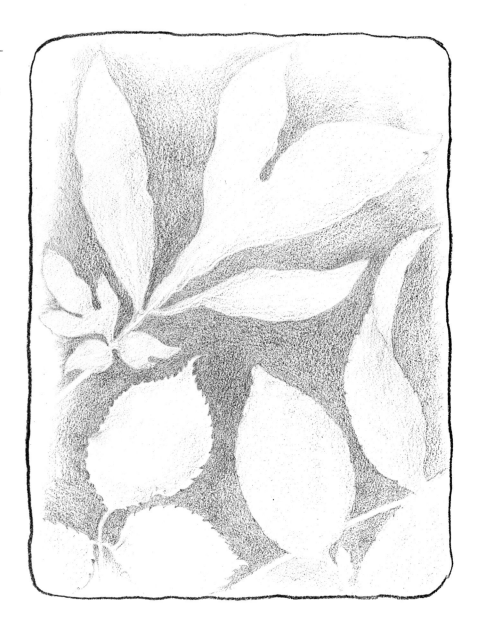

# FOLIAGE

## STEP 2

Green foliage is often expressed too brightly. Hues that are accurate enough to a leaf's local color in life can appear strident on paper. To avoid this, I began with a base color for each leaf that would tend to subdue their greens. Over the initial violet of the peony I used 909 Grass Green and 911 Olive Green. These layerings of color also further revealed the impressed lines.

   Over the initial red of the rose leaf and the yellow-green of the camellia, I used 911 Olive Green. I also drew some vein details with this green on the underside of the camellia leaf. More modeling of form was begun with changes in pencil pressures (resulting in value changes). Such pressure changes can be seen particularly in the camellia, indicating this leaf's reflectivity.

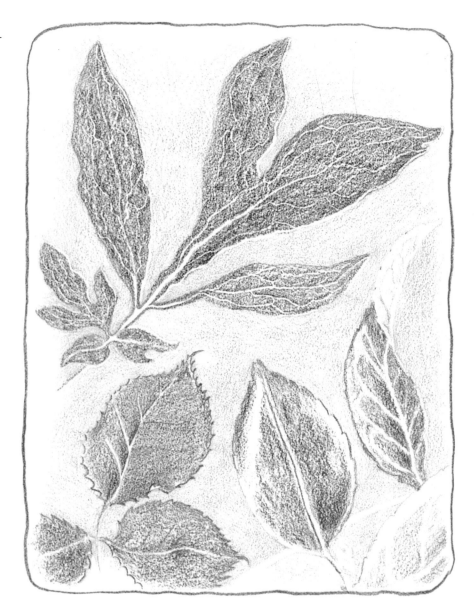

## DETAIL

A close-up view of the peony leaf shows some of the impressed lines representing veins. These can be altered by drawing into them if necessary. Another thing visible here is the way in which the paper texture combines with the colored pencil pigment to deposit clumps of pigment on just the "hills" of the paper's tooth. When drawing organic surfaces, these irregular clumpings can be exploited and emphasized. With leaves, they can be worked toward suggestions of veining.

## USING A KNEADED ERASER

Another way I express leaf surfaces is with a kneaded eraser. Pressed onto a drawing, such an eraser can lift some of the pigment up and away. (Be careful not to scrub with it.) On the peony leaf, I used this effect for irregular passages of light value. Notice the softness of these value changes compared with the harsher changes in the shiny camellia leaf.

## STEP 3

I added the final color to the background—a 931 purple—so I could judge how light or dark the negative space was going to be. This allowed me to more accurately assess adjustments needed in the leaf values.

Darker values were given the peony and the rose leaves with 901 Indigo Blue, using less of this on the warmer rose leaf. I also used the kneaded eraser to lighten some areas on the peony leaf. Finally, to punch up the contrast in the camellia leaf—and better suggest its glossiness—I used 901 Indigo Blue, 931 Purple, and 909 Grass Green. The kneaded eraser was also used again here, this time to slightly subdue a too sharp transition between highlight and darker values.

# 26. AMBIENT TEXTURE

In a drawing, there are often other textures besides those representing the surfaces of objects or things. These are textures more related in an overall way to the composition itself, and are what we might call ambient textures. They can enhance color application, suggest a tactile sensation, evoke a mood, or act as a unifier.

We have at least three ways of creating such ambient textures:

1. Paper texture—a pattern that derives from the paper itself.

2. Drawn texture—hatching or repetitive marks drawn directly onto the paper.

3. Surface texture—a result of manipulation or physical change.

It is the third of these—surface texture—that we haven't yet talked about. Some of the techniques for achieving it include uses of sgraffito, solvent texture (with an unpigmented marker), burnishing, impressed line, and what I call an "eraser wash."

## SGRAFFITO: STEP 1

A texture was developed here by scratching into a colored surface with a blade. Here Cray-Pas was used on paper prepared with acrylic gesso. A sgraffito technique can be used with any color drawing medium, so long as its surface can be built up slightly.

## STEP 2

Although I am using an X-Acto knife here, I also use a single-edged razor blade for this task—especially when using a sgraffito technique on unprepared paper. It takes care, and a bit of practice, to remove just the pigment material without scratching the paper.

## DETAIL

A gesso surface is not really re-
quired, but I like the nice white
lines it produces. Unprepared
paper reveals a slightly stained
surface from its initial layer of
colored pigment. Sometimes,
however, a slight hue might be
right, and pure whiteness wrong.
It all depends on what you want.

## WORKBOOK ASSIGNMENT

It may seem at first that colored
pencils cannot build up enough
surface for a technique such as
sgraffito; but in fact they do, and
very effectively at that.

To try sgraffito, you'll need
some kind of blade. For paper
without gesso, I prefer a single-
edged razor blade. Start by ap-
plying a few patches of color to
a page of your workbook—each
patch about two-inches square.
Use two or three pencils for
each, and vary your pencil pres-
sures. The pigments deposited
by these differing pressures will
show you how much build up
you will need for sgraffito to
work well for you.

Using just a little of the
blade's point, and some of its
side, draw or push the blade

through the pigmented material.
The width of your line is depen-
dent on how much "side" of the
blade you use. (With the whole
broad side of a razor blade, you
could quickly "erase" your
whole patch of color.)

Textural effects with sgraffito
are made by an approximate
repetition of marks throughout a
color area. If you'd like to pur-
sue this useful technique a little
further, try it with a gesso-pre-
pared surface. Ready-made
gesso can be found in most art
supply stores, and is as simple
to use as brushing it on paper
and letting it dry. If you try
gesso, be sure to also try draw-
ing directly onto it for still an-
other interesting textural effect.

# AMBIENT TEXTURE

## ERASER WASH: STEP 1

Here is a technique for producing a very loose and gestural texture, somewhat resembling a wash. For this example, colored pencils were used for the subject and its ribbon, and Art Stix as a beginning for the background.

## STEP 2

I next used a Mars Staedtler plastic eraser to compress and move the background's pigment material. The cleaner this type of eraser is, the more pigment it will remove. I like to let one end of my eraser build up with pigment so it will *not* erase, but will instead move and mix the colors. I keep the other end clean to get my lighter areas of "wash."

*COLORED PENCIL AND ART
STIX ON PAPER, 9" × 12½"
(22.9 × 31.7 cm).*

Although the use
of an eraser wash
is seen most
conspicuously
here as a back-
ground, some of it
has also been
used to help
soften the sub-
ject's edges.

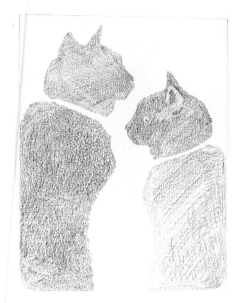

### IMPRESSED LINE: STEP 1

This method of impressing details into white paper can also be an excellent way of developing an ambient texture. To use impressed lines as a texture in this drawing of two cats, I began by loosely establishing the positive space with a colored pencil. The negative space was left blank.

### STEP 2

To impress the line work I wanted into the drawing's negative space, I first covered the area with a scratch sheet of tracing paper. Then, with an ordinary drawing pencil—and a fairly firm pressure, but not so much as to tear the tracing paper—I drew the lines into it.

### STEP 3

Removing the tracing paper, I tonally applied colored pencil across the area. This revealed the lines as white impressions in the paper.

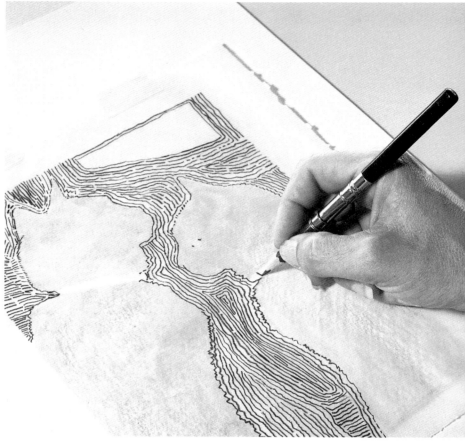

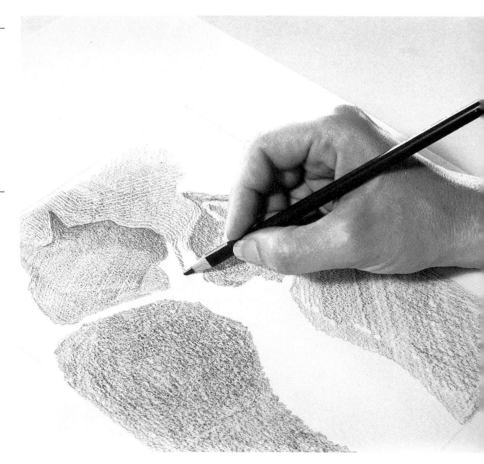

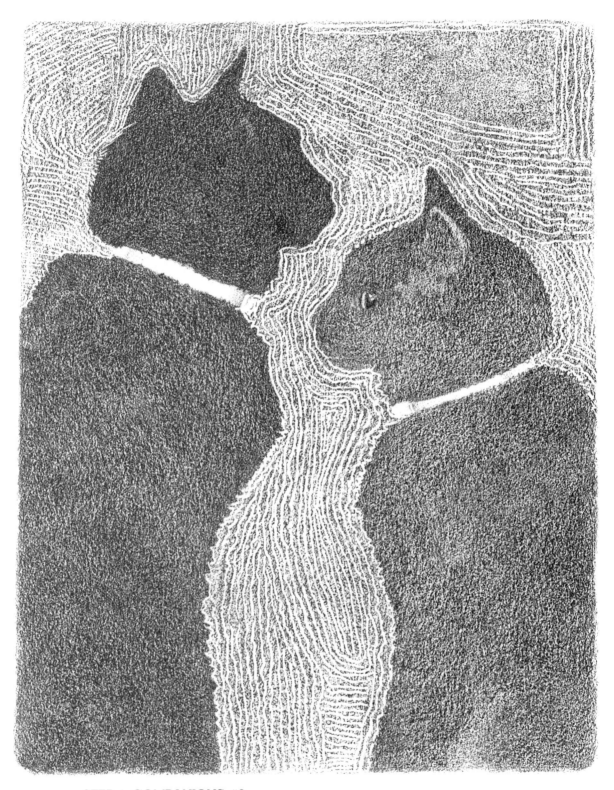

## STEP 4: COMPANIONS #2.

*COLORED PENCIL ON PAPER, 6⁷/₈" × 9¹/₄" (17.5 × 22.5 cm).*

You will notice that there is more than one texture in the completed drawing. There is the impressed line in the negative space, but there is also a texture in the cats. This second kind is an example of exploiting a paper's own texture. In the area of the cat's eye, however, you can see where the paper's texture was overridden by a use of heavier pencil pressure.

# AMBIENT TEXTURE

### BURNISHING: STEP 1

For achieving a surface texture by burnishing (a technique particularly suitable to colored pencils), a few layers of color are first juxtaposed alongside one another. In this example, I used (from left) 930 Magenta, 932 Violet, 933 Blue-Violet, and 903 True Blue.

### STEP 2

With a 938 White colored pencil, I next made a series of cursive marks with firm pressure over the previously drawn colors. A kneaded eraser was then used to lift out some of the original color. Areas burnished with the white pencil fail to yield to the eraser, and it is this failure that leads to an interesting contrast.

### DETAIL

This close-up view shows the contrast between the burnished and unburnished areas. Any light-valued pencil can be used as a burnisher, but if it is not a neutral (such as white) it will add its own effect to a final hue.

## COLORLESS BLENDER

To develop a surface texture with a Colorless Blender, first apply a light-to-medium-light layer of dry pigment to the surface. Then hatch over this with the marker which—as it liquifies the pigment—yields a darker and fluidlike mark.

## SOLVENT TEXTURE

Here is a texture made with an Art Stix and a Colorless Blender. These unpigmented felt-tipped markers are interesting tools, and we'll have more to say about them later. Meanwhile, a Colorless Blender can also be used for the making of ambient textures with colored pencils, Cray-Pas, oil crayon, oil pastels, and colored art markers.

# 27. DRAPERY

A fabric in a still life that only has one or two ironed-in creases is fairly easy to draw from simple observation. But when a fabric drapes into folds—as it does on a person or at a table's edge—it becomes more difficult to draw. It helps, in this case, to understand the two main principles for understanding and drawing the folds in cloth.

The first is that a fabric's folds radiate out from where it is gathered or held, or from where a body part presses against it. The second is that fabric reflectivity—and thus interior contrasts—can vary widely. For example, matte cotton would require much less contrast than the high reflectivity of shiny satin.

## SCHEMATIC DIAGRAMS

It helps greatly when drawing draped fabrics to be able to visualize them as simple forms. These diagrams show in a schematic way how planes and values change with the light in a single roll or fold of fabric.

In the example at A, the light is at the front. The lightest-valued plane is at the crest of the fold. The planes alongside the crest are light gray, and the valleys at its base are dark. In example B, the light comes from the right. Notice what this does to the values of the same planes. The more clearly you can show these plane changes, the more convincing your drawings of drapery will be.

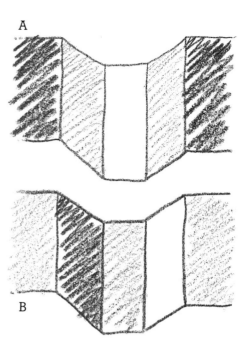

A

B

## PASTEL DRAWING

At first glance, this pastel drawing looks like a reasonable study of a draped fabric. When I originally set it up, I used an artificial light to emphasize contrasts. And that's the first way in which I went wrong.

I proceeded to draw the shadows and light areas where I found them, instead of thinking in terms of top, side planes, and base. The overall result is uneven—in the areas where the light source revealed the fabric planes fairly well, the drawing succeeds, but in other areas, the cast shadows have just about completely obscured the form.

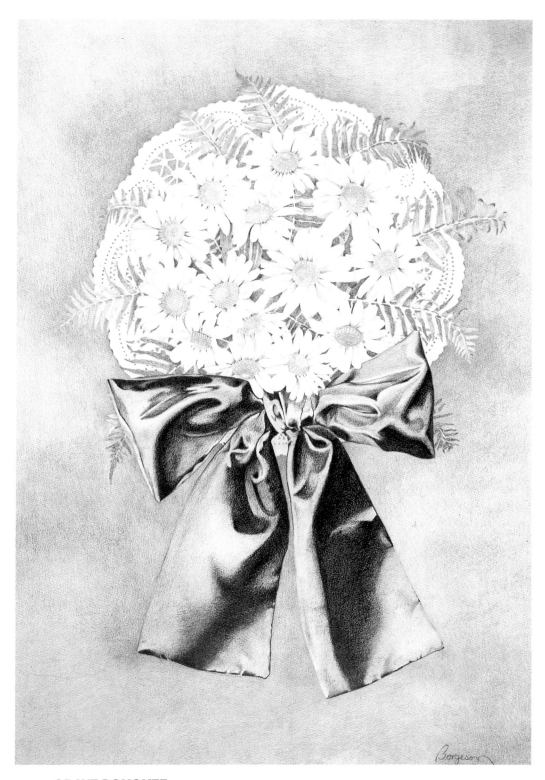

## GRAVE BOUQUET

*COLORED PENCIL ON PAPER, 17" × 24³/₄" (43 × 62.9 cm).*

Drawing bows is a great way to practice with fabrics. In this case, the fabric is a very reflective dark satin, so contrast was kept high. The bow could have been made to look like a glossy vinyl by still further lessening transitions between light and dark; or it could have been made a velvet, by minimizing its light reflecting areas.

## DRAWING ASSIGNMENT

Using our rule of visualizing distinct planes, let's actually go through the steps of drawing a draped fabric. Set up about a yard of soft cotton for your drapery—a striped piece if you can. Stripes in a fabric serve as cross-contour lines, which help us see the rise and fall of planes.

Pin your fabric to an upright board or wall in two or three places—four or five places if you'd like it more complex. The stripes can go in any direction.

Do not position a directional light on your fabric. The fabric shown here is lit by broad daylight falling frontally on it. It approximates the lighting in example A. Make a few thumbnail roughs to get an idea of how much of your drapery you want in your composition, and what you will do for your color scheme.

## STEP 1

For my drawing, I began with an HB graphite pencil, erasing with a kneaded eraser to make corrections. In this graphite step, I only drew the overall contours and striping. Some sense of the shadows was briefly indicated with construction lines, but no tonal development of lights or darks was done.

To get the benefit of a striped fabric and its contour lines, try as much as you can to maintain an almost tactile relationship among your eye, your pencil, and the stripes. Notice as you draw them how these stripes slightly widen and narrow as they rise and fall.

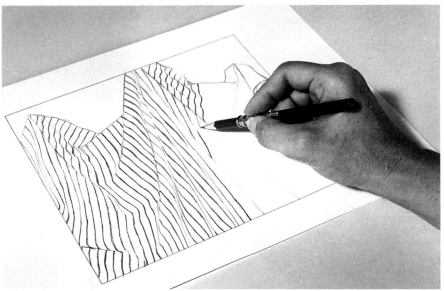

## STEP 2

I began using color by laying in some of the negative space with a 933 Blue Violet colored pencil. I also began to refine the stripes. As I worked at each area, I erased the graphite (only a ghost of it now remains) and drew with color. For the red local color of my stripes, I used three separate hues to aid their structure. In the area of a fold representing a crest, I used 922 Scarlet Red. For stripes on the side planes I used a darker 924 Crimson Red. And for the darkest and coolest areas of stripes, I used a 931 Purple.

Even though no modeling has yet been done, you can see the beginning of bulging contours. This is due to color changes and to varying the widths and positioning of the stripes.

## STEP 3

With the stripes as a guide, I began modeling the fabric itself with light and dark color values, and with cool and warm hues. I also laid in a second background color, a 948 Sepia.

As the background color of my fabric was yellow, I chose a 917 Yellow Orange as my basic hue. I rarely use pure yellow except as an ingredient in mixing. Yellow-orange seems to me somewhat gentler, and usually reads as yellow in context.

The area of fabric from left to center is now pretty much completed. The rest has been left incomplete so you can see how the color structure was built. Those parts of the fabric that recede were first described with a borderline cool hue, a 932 Violet. On the more fully developed left side, 929 Pink and 922 Scarlet Red were used also to serve as transitions from the violet to the yellow-orange. Some additional yellow-orange was then applied over these colors. An advantage (again!) of transparent colors is that they can be tied together so well for these subtle hue shifts.

A note about fabric contrasts: Squinting is a good device for determining where the lights and darks fall on draped fabric. To show those areas that are hidden by folds of cloth—called the undercut—render them very darkly. Also, if you look at the undercuts in my drawing of drapery, notice that there are no real highlights of white paper— because the fabric is a matte surfaced cotton.

# 28. METALLIC SURFACES

Context is a very important clue to the fact that a surface is made of metal. The shape of an object and where it is located—these are its context. A shovel, for example, is recognized instantly as metal, not fabric or glass. If we draw it using almost any grayish colors, its "metalness" will probably be readily accepted.

But when we can't lean this heavily on context, there are two other important clues for drawing various metals—surface reflectivity and color.

## SURFACE REFLECTIVITY

Metal is opaque. Unlike most materials, it does not of itself absorb light. It cannot—except for such surface substances and textures on it, such as rust, paint, scum, or corrosion—reflect back parts of white light as color. Although even the whitest paper reflects only about half the light that strikes it, a polished metal surface can reflect back almost all.

Another characteristic of polished metal is that it can—depending on the angle to our eye—appear to reflect back almost all the light or suddenly almost none of it. This characteristic affects us as artists because in order to show polished metal we must greatly heighten value contrasts. The stainless steel of the salad utensils on this page was drawn with sharp contrasts. To show the reflection of my studio windows in them, I used the white of the paper. Colors in the dark areas are reflections from the environment rather than a property of the metal itself.

An opposite extreme of the salad set's reflectivity can be seen in the garden trowel at far right.

Here, there are almost no highlights and the colors of rust (from yellow-orange to blue-violet) tell us still more about the trowel's metal surface.

The pliers between these two extremes are typical of what I would call a general metallic surface. The metal is reflective only where it has become polished from use, as at the handle edges. Its colors are the result of an over-all tarnishing on its surface. This is the kind of metallic surface—whatever the metal—that we will most often meet.

## METALLIC COLOR SWATCHES

Manufacturers of color drawing media frequently offer what they call metallic colors. Like flesh color, these colors offer a some-what simplistic approach; they also cannot be modulated with other colors. The problem with using specific metal colors is that metal surfaces (because of the various substances that coat them, and despite their own opacity) can display a color range from dull neutral to flashes of hue-laden brilliance—and sometimes all on a single small piece of metal.

Here are some colored pencil mixes that have worked well for achieving the look of metallic surfaces: (In drawing copper, for example, swatch 4 would likely get you into the ballpark—but you would still need adjustments for your specific copper object.)

1. Aluminum. Base color: 968 Cold Gray Very Light, with 936 Slate Gray added.

2. Silver. Base color: 968 Cold Gray Very Light, plus 948 Sepia, 932 Violet, and 903 True Blue.

3. General Metallic (any of a wide variety of hard-to-classify metal surfaces. Often seen in metal that is old or has lost its original polish.) Base color: 936 Slate Blue, with 933 Blue Violet, 909 Grass Green, and 937 Tuscan Red.

4. Copper. Base color: 929 Pink and 918 Orange, with 948 Sepia, and 909 Grass Green added. (For oxidation, also add 903 True Blue and 910 True Green.)

5. Brass. Base color: 917 Yellow Orange, with 948 Sepia, 903 True Blue, 918 Orange, and 932 Violet added.

6. Bronze. The same mixture as brass, but with 922 Scarlet Red added.

7. Gold. Base color: 916 Canary Yellow and 918 Orange, then 913 Green Bice, 905 Aquamarine, and 922 Scarlet Red added.

As an example of how differently these mixtures appear in and out of context, note the use of mixture 3 as it appears in the pliers. Remember when mixing colors for metallic surfaces to let some of the hues remain separate and unmixed as a suggestion of sparkle or glint.

1.

2.

3.

4.

5.

6.

7.

**PART FOUR**

# DRAWING WITH WET MEDIA

Many color drawing tools can be used wet as well as dry. In these next few lessons we demonstrate ways of drawing with brushes, using both turpentine and water as solvents. We will also mix colors with an unpigmented marker, and consider some alternative drawing supports.

# 29. BRUSH DRAWING

There is a long tradition of drawing with brushes, and this is something you may now want to explore with color. An advantage of several color drawing media is that they can be used dry, wet, and then dry again—all in a single area, and all with the same pigments.

## TURPENTINE-SOLUBLE MEDIA

Turpentine is a good solvent for many color drawing tools, including colored pencils, color sticks, Cray-Pas, oil pastels, and crayons. For all these, basic mixing methods are the same. Dry pigment is loosely applied—in single or multiple layers—then a brush containing turpentine is worked into the area, releasing the dry pigment from its binder.

## WATER-SOLUBLE COLORED PENCILS

Some colored pencils are formulated to dissolve easily in water. This allows for a very fluid effect, such as in the sketch shown here of lemons. The trade-off with easy-to-use water-soluble pencils, however, is a marked lessening of color permanence; their resistance to light fading is only fair to very poor. However, when this shortcoming is not a factor (as for work planned only to be soon printed or photographed), then these water-soluble pencils can be truly a joy to use.

## DELIVERING THE COLOR: STEP 1

In this sketch, water-soluble colored pencils were first loosely applied to a sheet of cold press 140 lb. watercolor paper. (The more pigment first applied, the stronger the color result). Using a wet #10 round sable-type brush, I then began moving and mixing the color.

   (This way of using pencils, by the way, is a good way of "freeing up" if you feel that you draw too tensely. The dry colors are laid in quickly, almost haphazardly—just the opposite of a precision approach.)

## STEP 2

After waiting a few minutes for the brushwork to dry, I added some additional dry pencil color over the wash areas. This waiting-to-dry period, incidentally, is almost nonexistent when using turpentine with pencils that are not water-soluble.

## WATERCOLOR APPROACH

An alternate way of delivering color is to use pencil pigment in a manner similar to how you would use watercolor. Here, you can see that some pencil pigment has been applied to a piece of scratch paper, then dipped into with a wet brush. The brush—after loading it with color—is used for drawing directly.

# BRUSH DRAWING

## FRUIT ON BLUE PATTERN

*COLORED PENCIL AND TURPENTINE ON PAPER,*
*8″ × 11″ (20.3 × 27.9 cm).*

A wet drawing method was used for the fruit in this still life. I first established some color and form very quickly with dry pencils. With turpentine and a #3 round white bristle brush (a stiffer brush is needed for non-water-soluble pigments), the colors were then moved and blended gesturally. Some of the paper whites were preserved as highlights. As a final step, I scumbled some contrasting dry pencil hues back over the forms to suggest texture.

## DETAIL

In this close-up detail, you can see how the scumbled pencil colors rest on the peaks of the paper's tooth. You can also see how they mix visually with the colors that were liquified earlier with the turpentine.

# BRUSH DRAWING

## DOUBLE PEONIES
*CARAN D'ACHE COLORED PENCILS ON PAPER,*
*10" × 11¼" (25.4 × 28.9 cm).*

Wet and dry methods of using water-soluble colored pencils are combined in this drawing. The flowers were loosely drawn with a brush, while sharper details of the vase were drawn with pencil.

## CHARGING WITH WET MEDIA

To charge a wet-worked area with additional color, simply hold a colored pencil tip in the wet area for a few seconds. This works well with pencils designed for either type of liquid—turpentine or water.

## DETAIL 1

This detail of the top peony's petals shows the high-key fluid effect that is typical of brushwork with water-soluble colored pencil pigments. In this particular area, very little additional drawing was done after the wet stage.

## DETAIL 2

This shows some of the tonal brushwork for the petals and leaves, and the more linear work—done with dry pencils—in the vase area. This is an example of the same colored pencils used both wet and dry.

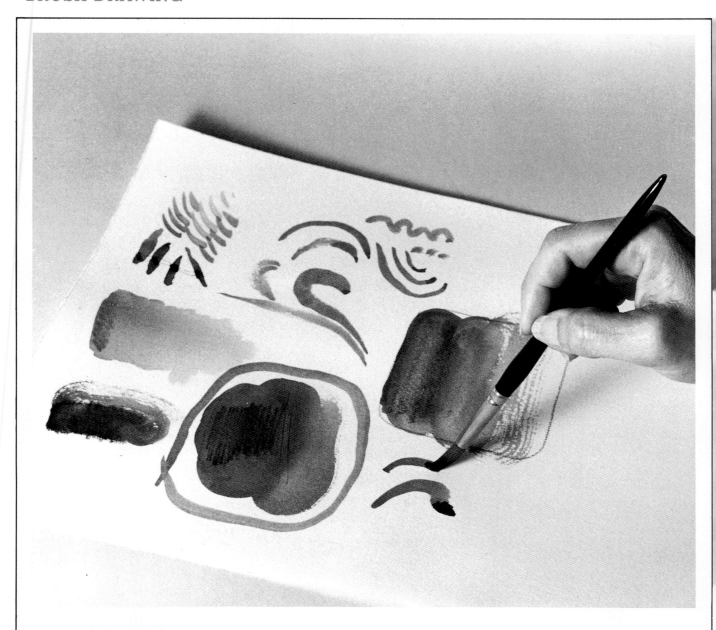

## WORKBOOK ASSIGNMENT

The important difference between traditional watercolor brushwork and the kind we have been discussing is that with watercolor painting we begin with a brush that already contains the color. When we use color drawing media and a solvent, we are usually liquifying colors *on the paper.*

You can practice brush drawing in your workbook, but I think it is better to practice on larger sheets of paper, with plenty of room to move the brush around. Also, if you are using water-sol-

uble colored pencils you might try a watercolor paper with a surface texture similar to your regular drawing paper.

Try both kinds of pencils (water-soluble and non-water-soluble) to experience for yourself their good and bad points. If you are new to drawing with a brush, you may find yourself gripping it too tightly and too near the metal ferrule. Try holding it about halfway up its handle (as shown), with your arm up off the paper.

Drawing with pencils and

brush is basically a two-step process. The first step is laying in pencil pigment on the paper. The second is placing a wetted brush into the pigment, pausing for a second or two (just long enough for the liquid to begin releasing the pigment), then moving the pigment with a light stroke of the brush. Practice delivering color in this way until you can gradate a wash. Also practice your brush strokes with varying length, shape, and pressure. Getting articulate with a brush means lots of practice.

# 30. ADDITIONAL TECHNIQUES AND SUPPORTS

Several of the techniques for handling transparent watercolor painting can also be applied to colored drawing media and solvents.

## TECHNIQUES

A. This technique is similar to a traditional "resist." The diagonal strokes were made with non-water-soluble colored pencil. The wash was then made with water-soluble, the diagonals resisting the action of the water. This is a good way of applying washes over colored pencil without disturbing an original drawing.

B. The two light areas are a result of "lifting-out," and can be done with either turpentine or water. It's simply a process of blotting some color (with sponge, cotton, or tissue) up and out while the pigment is still wet.

C. When salt is sprinkled into wet color and left to dry, it results in a mottled and textured effect. This works with water, but not with turpentine.

D. Watercolor's traditional "spatter" techinique is duplicated here by running my thumbnail across an old toothbrush loaded with pencil color.

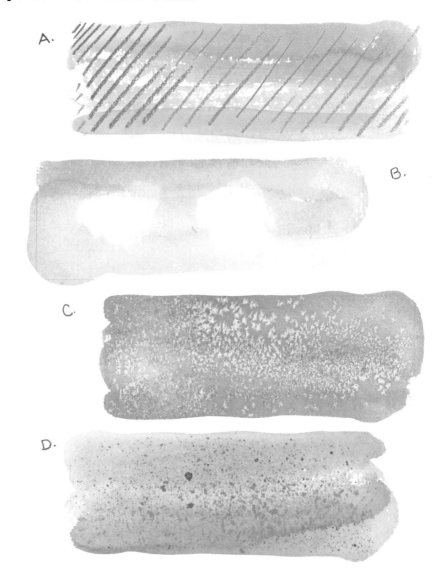

## SUPPORTS

Although paper is generally assumed to be the surface used for drawing media, brush drawing can also be done on a variety of surfaces. In this example, Prisma-color pencils—liquified with turpentine—have been applied to regular artists' cotton canvas primed with a coat of acrylic gesso. I think a gesso surface—on canvas, panels, or paper—makes the best possible support when turpentine is used as a solvent. Besides not staining (as paper does with turpentine to some degree), it also makes erasures possible.

# 31. UNPIGMENTED MARKERS

Unpigmented markers are felt-tipped markers containing no color of their own, but only a clear solvent. They can be used to blend and manipulate the colors of many drawing media—including colored pencils, color sticks, colored markers, Cray-Pas, oil pastels, and crayons.

## STILL LIFE WITH TOMATOES

*COLORED PENCIL AND COLORLESS BLENDER ON PAPER, 9" × 12" (22.8 × 30.4 cm).*

Another way of using colored pencils with a solvent is shown in this drawing in which non-water-soluble colored pencils have been liquified with an unpigmented marker.

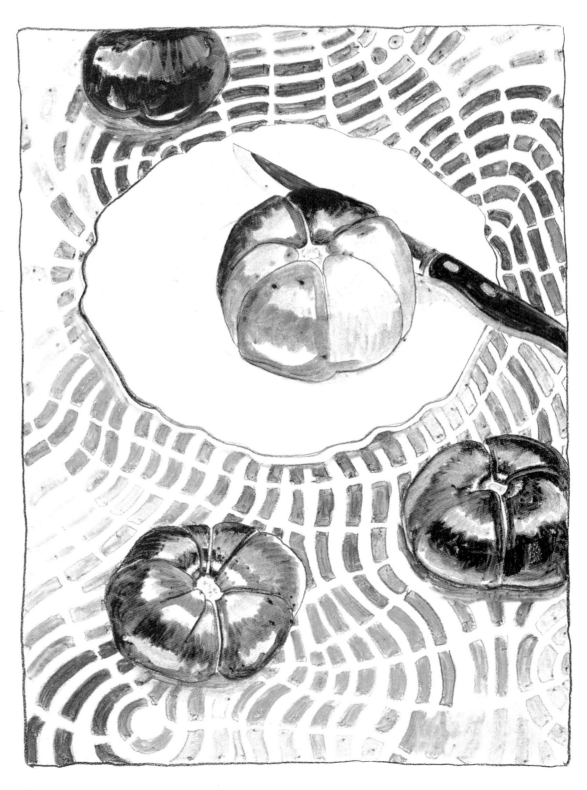

## DETAIL

A close-up view of my still life's lower left tomato shows the effect of an unpigmented marker over colored pencil. The lightest areas are untouched paper. The darkest areas are where most of the pencil pigment was applied. Medium values were drawn only with color picked up by the blender's nib— and now occupy areas where no pencil pigment was used. A marker's stout felt tip provides good friction for moving the loosely applied pencil pigment around.

## COLORLESS BLENDERS

A Colorless Blender #311 (made by Eberhard Faber) is shown here liquifying pigments of Prismacolor colored pencils. It can be used linearly through the pigment (top), or tonally to fuse the material (bottom). When you use an unpigmented marker, keep a sheet of scratch paper nearby to run out the felt tip's picked up colors. You can also sometimes run out color in other areas of a drawing needing light values of the same hue.

# DEVELOPING A CRITICAL EYE

In the final group of lessons, we investigate some areas of color drawing in which personal judgment plays a large part. We will try to show why some ideas read very clearly while others fail visually. We will look, too, at ways of coping with subject complexity by seeing in terms of simple masses, and with how effects of unity can be achieved.

A seldom discussed topic addressed here is how to start making personal progress again when seemingly stalled. We will show some ways of breaking free from color clichés, and of how to use photography as a source (and not be fooled by it). Finally, seventeen special projects are offered, which are designed to continue your own work and growth in color drawing.

# 32. SHOWING AN IDEA IN ITS CLEAREST FORM

There are some aspects of drawing that relate more to our aesthetic judgment than to our technical skills, and showing things clearly probably relates to both these areas.

It is always important in art to show our ideas in their clearest form. This doesn't have much to do with a particular idea's scope but has practically everything to do with its ultimate strength. However, there are at least three big pitfalls that can prevent us from achieving clarity.

## CLARIFYING OUT-OF-CONTEXT SUBJECT MATTER

A third obstacle to clarity happens when we become so well-acquainted with a concept or an object that it clouds our objectivity. These photographs show how a familiar object (and it could have been a concept or idea less tangible than a pear) can become an unintentional mystification.

Suppose, as in the first picture, we pose a little group of what anyone will probably accept as four pears. We know them to be pears by their familiar shapes and colors and also—in the case of the pear at far left—by the clue of context.

But then suppose we change our minds for one reason or another, and in changing our setup we lose our context clue. And suppose—because of our own familiarity with the pears—we no longer notice that nothing else remains to explain that object at far left.

Is it still a pear? Would anyone who hadn't seen the first photograph think so? What we are left with, when something of this kind happens, is an ambiguity that no amount of color work or technical ability can overcome.

The first of these pitfalls can occur when we are working spontaneously and very energetically but haven't thought about just what it is that we want to convey. So before rushing into a drawing, we must remember to pause long enough to decide just what the idea is that we want to show. How will anyone else understand our ideas if we don't take the time to fully understand them ourselves?

A second pitfall is what I call "taking the first solution." There is almost always more than one answer to the question of how best to present an idea. The first answer to occur (and sometimes also the second or third) is more likely than not to be something overly familiar. All of us are bombarded with incessant messages from the popular culture surrounding us; so if our own ideas are to emerge with strength—or even to look as if they are our own—we must grow suspicious of these first and easy answers. As artists, we must try digging deeper to find what we want to say in our drawings.

# 33. MAKING ART OUT OF ART

Another problem with clarity can happen as a result of drawing from other artwork, such as figurines, pieces of pottery, or photographs. Ambiguities enter our drawing because we include the original artist's or craftsperson's distortions, or because we try to transfer the effects of one medium or material to another idiom. In either case, the viewer who has not seen the source may be very confused by the drawing of it.

## AMBIGUOUS SUBJECT MATTER

Here is a drawing that suffers from the problem of drawing art from art. If you weren't told, would you know its subject to be a candle? In this instance, even the photographic source is obscure.

Unexplained, the candle might be mistaken (out of its original context, and in its new idiom) for a bunch of flowers. More guesswork by a viewer might or might not account for why the flowers are so thickly drawn, and why a strange egg shape lies at their base. The point is, accurate as it may be to its actual source, a drawing of this kind lacks clarity—and to a viewer may simply look like a lack of skill.

I think it is a good idea to avoid using an art object as the single subject for a drawing, unless we can create a context for it. More candles, for example (maybe plainer ones) might have given our fancy candle composition a better chance. But better still, if there is something so compelling about an object that you feel you must draw it, then I think what you must try to draw or express is that very attitude—rather than merely the object itself.

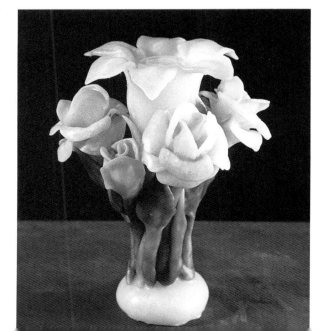

# 34. SEEING SIMPLE MASSES

A composition that looks too cluttered or disjointed, or lacks a feeling of unity has probably not been organized into its most simple divisions or masses. When we draw from reality, we often have enormous amounts of detail thrust at us. Much, and sometimes even most, of this detail must be edited or even eliminated.

Because we all see differently, the simple masses needed for a good composition will be chosen differently, and according to our own personal vision. But in one way or another, we must find our simple masses. These can be formed by shape, value, color, positive/negative space, texture, or on the relative importance of various elements.

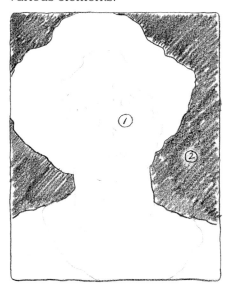

## PRELIMINARY SKETCH 1

If you are having trouble visualizing the primary masses of your subject, try placing them in a preliminary thumbnail sketch. Here is how a portrait might first be organized into its two simplest elements—its positive/negative masses.

## PRELIMINARY SKETCH 2

In a second sketch, I have added a few more simple masses, showing more information. There are now five masses based on shape and color. Detail has been omitted, with only a suggestion of large value relationships to describe facial-plane changes. From this step—with some evidence that my composition is clear and my forms solid—I can proceed with my drawing with more confidence.

### HYDRANGEA

*COLORED PENCIL ON PAPER, 9³/₄" × 12³/₄"*
*(24.7 × 32.3 cm).*

This is exactly the kind of composition that could have ended by being too complex and too cluttered. To avoid this problem, I tried as I worked to see the drawing as two major areas—its positive and negative spaces. I then kept the negative space dark to contrast with my complex subject.

Bel Bergeron

# SEEING SIMPLE MASSES

### PHOTOGRAPHIC SOURCE

We are especially likely to get too much visual information thrust at us when we are out on location, drawing a scene from life. On first looking at this dockside scene, for example, it seems almost impossible to know where to begin. But at times like this, the sinking feeling of despair we get is what should signal us to start looking for simple masses. Our first questions must be: what is my subject here and what is my idea about it?

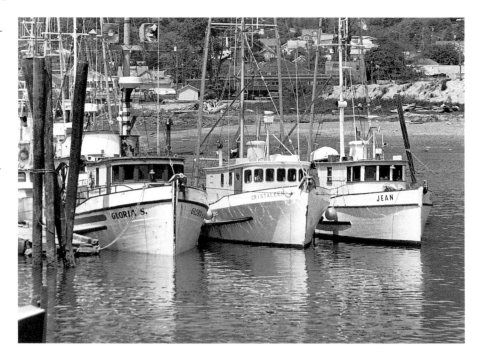

### PRELIMINARY SKETCH

Here is a preliminary sketch of the basic masses that might offer a start for drawing the scene. The idea behind the drawing is to show the three boats as pleasant companions.

Notice how the material contained here has now been organized into three simple masses. The first of these is my subject—the three boats, with a bit of dock; the pilings; and part of a fourth boat near the pilings. The second mass is the water surrounding the boats. The third mass is the shore and hillside behind the boats; the buildings and various other details—which will be subordinated—are included here also.

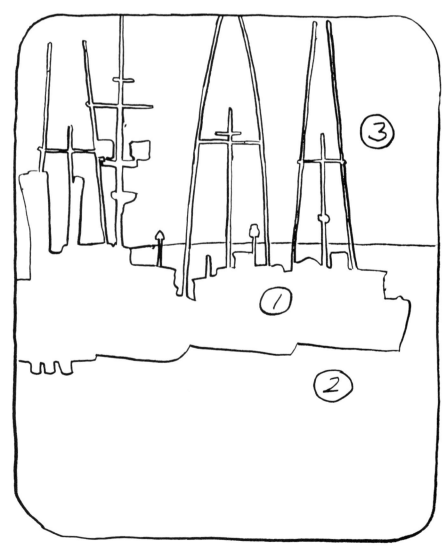

### WORKBOOK ASSIGNMENT

Organize the harbor scene in another way. Try different arrangements of its possible masses in two or three thumbnail roughs. Refer back to various criteria we have talked about for organizing masses. Since our photographic source is only in black and white, it might be interesting to organize its masses, in one rough at least, based on a color scheme of your own choosing.

# 35. INTEGRATING SUBJECT AND BACKGROUND

I think that for those of us who draw, one of the first charms about drawing (compared to painting, for instance) is how it lets us focus on intricacies of form. We like the way drawing can deal with things in sharp detail.

But it is also this liking for detail that frequently causes us to "objectify"—to become so intent on a subject that we fail to see the whole space it occupies. We focus too late (if at all) on our subject's background, which is then left empty, or as only a tenuous element. Objectification can often lead to a subject looking pasted onto its background, and pictures of this kind often look unfinished, as well as a little unreal.

We can almost always improve a drawing's unity, and achieve a more complementary relationship between a subject and its background, by remembering these principles about composition:

1. A background is not a flat, two-dimensional element; it is a containing and volumetric space. Our subject lies always *within*, not propped against this background.

2. We must try always to work our whole drawing together, trying not to let our main subject plunge ahead of lesser elements. Adding in a background after the fact seldom fools anyone (including ourselves), and can drastically change a subject's impact. This "working-it-all-together" is why we need thumbnail roughs.

Here are several specific methods for integrating subjects with their backgrounds:

1. Edge tie-ins, using similarities of color and/or value.

2. Using a specific hue as a common color denominator for all color mixing in subject and background.

3. Using an overall background pattern.

4. Avoiding halo effects caused by "coloring-in" of backgrounds.

5. Enlarging subject, and therefore reducing negative space.

6. Blurring some of a subject's outside contour edges.

7. Feathering out lesser parts of a subject into the white of the paper.

8. Tilting viewpoint to reduce negative space.

9. Echoing hues and temperatures from subject to background.

Remembering, as always, that the usefulness of these methods depends on appropriateness to your own intent and style, and on your personal judgment, let's look at some of them in greater detail.

## DRAWINGS WITHOUT BACKGROUND

A drawing with no thought given to background usually appears as an isolated object centered in a rectangle. In this case, merely adding a background would pose new problems, as all the color drawing decisions were based on white paper surrounding the subject. (An approach to the background problem for this particular drawing appears in Lesson 26.)

# INTEGRATING SUBJECT AND BACKGROUND

## EDGE TIE-INS WITH COLOR AND VALUE

In our concern with drawing a form, we sometimes get too meticulous about keeping its outside contours separate from the background. This can leave our subject looking very isolated. In this drawing, some flower edges have been allowed to dissolve into negative space, giving the flowers as a whole a more comfortable integration within that space.

Additionally, in the flower at bottom, the yellow-orange petal has been kept very similar in hue to its immediate surroundings. The curling petals of the other flower are also of a similar yellow-green to their adjoining negative space. Besides such hue matching, there is some matching of values.

Edge tie-ins of this kind are easiest to make where forms naturally begin to recede. But they can also be used—and effectively so—in foreground areas.

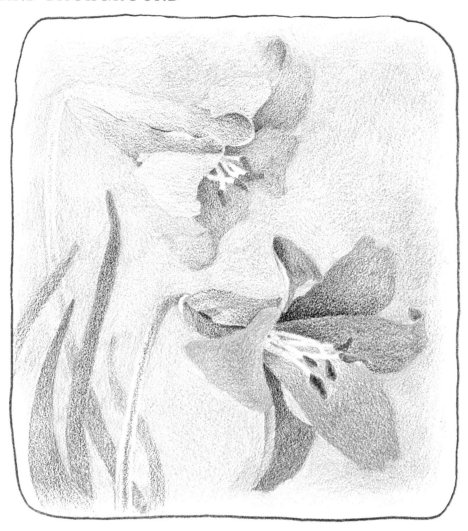

## USING A "COMMON DENOMINATOR" COLOR

This small color drawing has a feeling of good subject-background integration, even though the flowers seem quite distinct from their background. What unifies them is a color harmony achieved by using one specific color—in this instance, blue—as a basis for the color mixing in all elements.

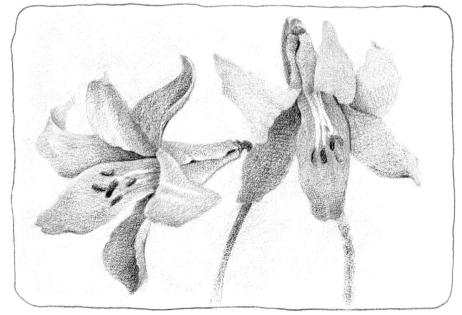

## LILIES ON LACE

*COLORED PENCIL ON PAPER, 6" × 8¼"*
*(15.2 × 21 cm).*

I often use pattern as a background element. It makes the negative space a tangible—not air or atmosphere, but something occupying a specific plane.

The lace pattern here—like most patterns—has a tendency to come forward. If such compression of space isn't wanted, a pattern can sometimes be cooled or darkened to hold it farther back (see patterned negative space of drawing on page 103).

# INTEGRATING SUBJECT AND BACKGROUND

## AVOIDING HALO EFFECTS

A halo effect happens when a subtle rim of lightness develops between subject and background. It is not always immediately apparent, but it nonetheless produces a feeling of separateness among elements. When done unintentionally, as in this line drawing, it is usually a result of "coloring-in" a background, working toward—but not quite to—the contour edges of the subject. To avoid this effect, negative space must be thought of as continuing on behind a subject, rather than merely skirting its edges.

## ENLARGING THE SUBJECT

Enlarging a subject beyond a frame of reference—as can be seen in this preliminary sketch of melon and grapes—draws a great deal of attention to the subject and lessens the significance of its negative space. Background can be handled as a minor element.

## BLURRING CONTOUR EDGES

In this unfinished drawing, the grapes at the center are fairly hard-edged, while those at the sides are blurred and indistinct. Blurring some (but not all) of a subject's contour edges helps integrate a form into its enveloping space. Conversely, hard-outlined contour edges tend to stand out separately from their surroundings.

## VIGNETTING

The feathering out of this jar and its top to plain paper is called vignetting. It serves as a good background treatment (or lack of treatment) for drawings that are meant to read as unstructured or informal. It is especially useful when there is nothing to be gained from a larger frame of reference for a subject.

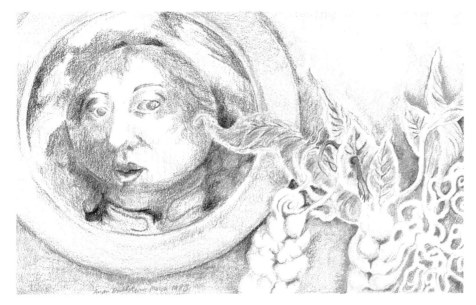

STUDENT DRAWING

*SUZAN DAHLSTROM. COLORED PENCIL ON PAPER.*

This is a drawing in which the term "background" hardly applies. Positive and negative space are nicely integrated, and an interesting interplay exists between them. Among the means by which the student accomplished this was her use of color—earthy red-oranges and yellows—in positive space, then an "echoing" of these hues in negative areas.

With our earlier mentioned hue and value tie-ins, similarities exist only in the immediate areas where a form's edge meets negative space. In our "echoing" method, similar colors and temperatures do not have to be closely connected physically.

## DRAWING ASSIGNMENT

To experience how a subject can be integrated with its background, let's take for our subject a graphic element that ordinarily resists integration—the blocked-out letters of our own initials. We will combine a blurring of some of their outside edges, some color tie-ins, and some "echoing" color.

Use any color drawing medium you prefer, and a sheet of white paper. For pastels, crayons, or color sticks, you'll need a fairly large sheet, about 18" × 24". With colored pencils, it can be smaller. Mark off a frame of reference with graphite, and within it—very large, but not so large as to crowd out all negative space—sketch in the letters of your initials. Make them

blocklike as shown. They don't have to be sign-perfect, just simple and graphic.

As you begin drawing with color, try not to worry too much about the edges of your letters. Move in and out of the letter shapes freely, not saving certain color mixes only for them. Rather, let the values and colors within the letters be the same as some of the values and colors outside them. Work your drawing all over as you proceed—not letting one area develop ahead of others. Try to maintain letter identities, but vary their edge clarities. One way of doing this is by using a kneaded eraser to lift away color and definition.

Deciding when a drawing is finished is always a matter of personal judgment. It lies in answering the question, one way or another, of: Have I shown enough yet of what I wanted to show? What you want to show this time is your subject (your initials) enveloped in an atmosphere, rather than planted squarely against a flat background.

TOM'S BOARD

*COLORED PENCIL ON PAPER, 16" × 19⅝" (40.6 × 49.9 cm). COLLECTION JEFF AND SUSAN WALTER, PORTLAND, OREGON.*

The subject is so compressed against its negative space here that there is little reason to regard the background as a separate element.

111

# 36. THE PART HUE SCHEMES PLAY

There is one aspect of drawing in which I think colorists are at risk in a special way. The very characteristics that make an artist a colorist—being sensitive and inventive with color, not afraid to "push" it, or to assign it such tasks as helping build modeling or structure—are those characteristics that can make him or her sometimes lose sight of color wholeness.

To be satisfying, a color drawing must usually contain a sense of overall color wholeness, which is an element in a drawing that is in addition to the individual colors. It is an important part of a drawing's balance or general harmony. I think our best hope of achieving such wholeness of color, while at the same time imparting feelings of lively color interplay, lies in a good understanding and appreciation of hue schemes.

A hue scheme, in simplest terms, is a selection or arrangement of hues that relate to one another. Hue relationship in a scheme can be harmonious or disharmonious. Most hue schemes—of the infinite variety possible, all with differing charateristics and effects—can be grouped under five headings:
1. Monochromatic
2. Analogous
3. Complementary
4. Triadic
5. Random

Let's look more closely at what these names mean to us.

## 1. MONOCHROMATIC HUE SCHEMES

These use only one hue. But the color's other two dimensions—value and intensity—may be varied. Neutrals may also appear in a one-hue scheme.

A monochromatic scheme is the least chancy to use, because working with only one hue brings with it an automatic color harmony. I find it is a good scheme for suggesting moods of blandness, refinement, or asceticism when such a mood is wanted. It also works well for drawings that at first sight are to appear achromatic—possessing no hue—but on closer inspection prove to have a subtle color content.

## 2. ANALOGOUS HUE SCHEMES

Analogous schemes utilize neighboring hues on a color wheel. One hue usually dominates, and a second is more conspicuous than the third. (With all multiple hue schemes, it is usually good practice to limit the number of hues in use to about three.)

Analogous schemes are also relatively risk-free. Being near one another as they are on the color wheel, they already possess a fairly close harmonic relationship.

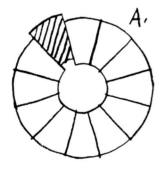

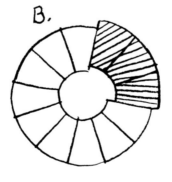

## HUE SCHEME RELATIONSHIPS

In these little sketches we can see at a glance how most of our hue schemes relate to themselves and to the rest of a color wheel. These relationships are:

A. Monochromatic. Color variables here are limited to value and intensity only.

B. Analogous. Variables now include hue itself as well as value and intensity. But the hues remain closely related.

C. Complementary and D. Triadic. Because the hues in both these come from very different portions of the color wheel, their variables are further increased. Although sometimes harder to control than the first two, these also offer more opportunity for achieving resonance, complexity, and liveliness in a hue scheme.

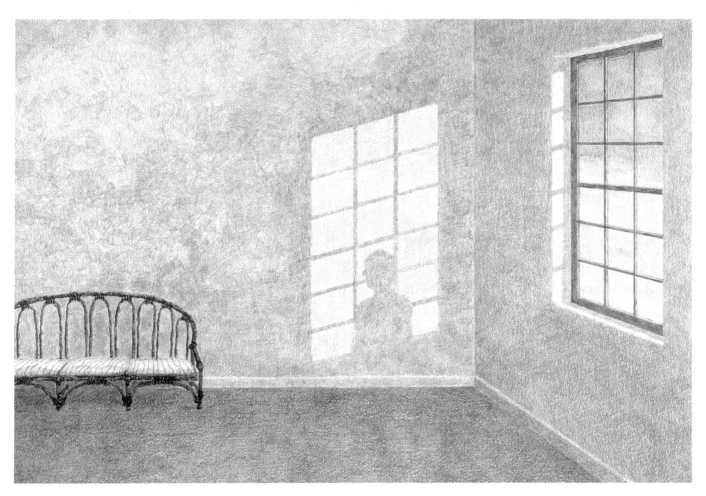

## STUDENT DRAWING

*TED FUSBY. COLORED PENCIL ON PAPER.*

For me this drawing possesses a monochromatic hue scheme, even though, in the strictest sense, it contains more than one color. Its overall "wholeness" color, however, is yellow; and the other hues seem conceived as modulations of yellow.

It is important to remember here that one basic type of hue scheme does not necessarily exclude all other hues. Additional accents and even subsidiary hue schemes can all exist within a drawing.

## STUDENT DRAWING

*DOROTHY PARIS. COLORED PENCIL ON PAPER.*

This drawing contains an analogous hue scheme. Why not monochromatic, with a colorist method of modulation? Because the color of the cherries (red, red-violet) and the color of the negative space (red-violet, violet) actually read as two distinct hues, not as a single hue altered by modulation.

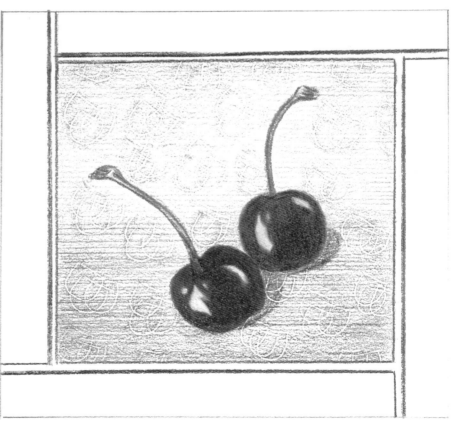

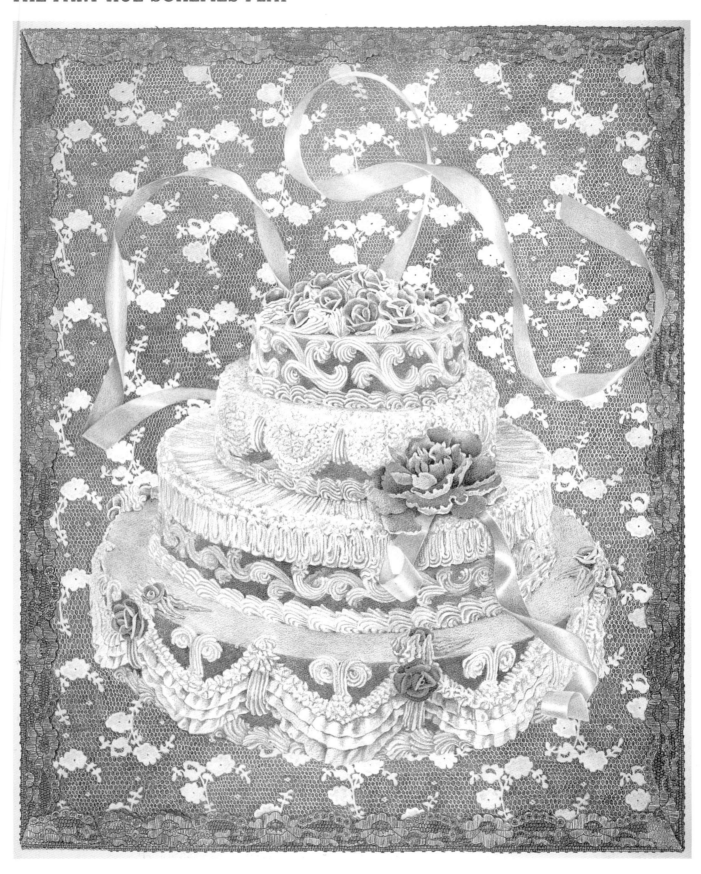

## 3. COMPLEMENTARY HUE SCHEMES

Hues in these schemes are directly opposite or very nearly opposite one another on the color wheel. A variation is the split-complementary scheme, which uses hues flanking an opposing hue. Because complementary schemes utilize hues from opposite sides of the color wheel, they can result in some very vigorous and hefty color combinations.

## 4. TRIADIC HUE SCHEMES

On a twelve-hue color wheel, combinations of three hues at equidistant intervals make up the four possible triads. Specifically, these three-pronged combinations are:

1. Red, yellow, blue.
2. Red-orange, yellow-green, blue-violet.
3. Orange, green, violet.
4. Yellow-orange, blue-green, red-violet.

Like the complementary schemes, triadic schemes can also be very lively. A triadic scheme is, in fact, regarded by some as a split-complementary scheme with the angle between near-complements widened.

## ZENOBIA'S CAKE

*COLORED PENCIL ON PAPER, 20½" × 25½" (52 × 64.7 cm).*

In this color drawing, a split-complementary hue scheme is apparent. Its three basic colors are the blue in the netting of the negative space, the red-orange of the lace, and the yellow-orange of the cake.

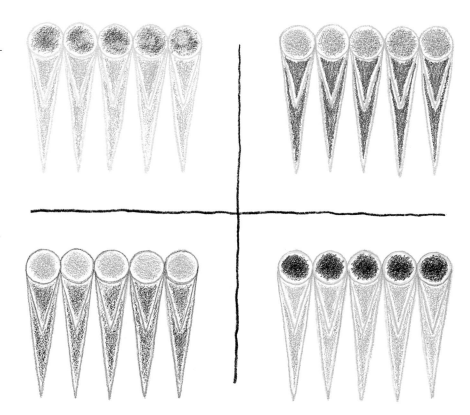

## FOUR TRIADIC SCHEMES

To better see the four different triads in these designs, cover the three you are not looking at. The scheme at top left contains red, blue, and yellow. These hues happen also to be the primaries, which gives them a great deal of color clout. They are so strong in fact, that it might be difficult to actually work with a scheme containing all three of them at their full intensity.

Below this is a triad of orange, green and violet. Because these are secondary hues, the scheme they produce seems subdued.

The triadic scheme at top right contains red-orange, yellow-green, and blue-violet. For me, this scheme contains a very natural expression of light and shade. The red-orange represents the lightness, the blue-violet the cool shade.

In the final scheme below it, the triadic arrangement is of yellow-orange, blue-green, and red-violet. I think of this hue scheme as being a little like seeing a triad of primaries (red, blue, yellow) but seeing them slightly out of kilter.

## 5. RANDOM HUE SCHEMES

I used to be skeptical about random hue schemes, thinking them too haphazard to offer much stability; but I have learned since that the word "random" is somewhat misleading. Although the hues themselves are selected at random, in order for them to work, they must be linked together by intensity or value, or by both. It is this limitation that allows otherwise random hues to contribute to a sense of color wholeness.

The six hues in the top scheme contain a similarity of brightness. Random bright hues work especially well when a great deal of white is also included.

The bottom scheme was based on random hues of low intensity. As an additional unifying element, I first tonally applied a blue-gray. See what a difference exists between these two random hue schemes: the first might suggest hard candy, the second, with a bit of imagination, a mood of cattle and branding irons.

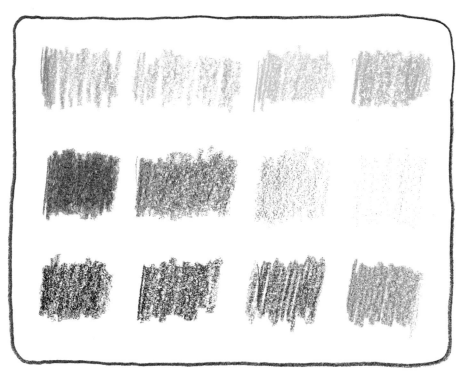

## COLOR PROGRESSIONS

These are not hue schemes, but deal rather with our handling of colors within a scheme. They are orderly variations in one or more of a color's three dimensions. Here are a few examples of orderly progressions by color dimension. In the top row, hue is varied from violet to blue-violet to blue to blue-green. Low-key to high-key values of blue are shown in the center row. And in the bottom row, only the color's intensity is progressively changed—from dull, brownish orange to bright orange.

## WORKBOOK ASSIGNMENT

A basic thing to remember about almost all hue schemes is that their two dimensions other than hue can be varied almost infinitely. Here is a triadic hue scheme of red-orange, yellow-green, and blue-violet. The three different versions are a result of varying intensities and values. In your workbook, with this design or one of your own, make several additional versions of hue scheme as well and some other hue schemes—by varying only color intensities and values.

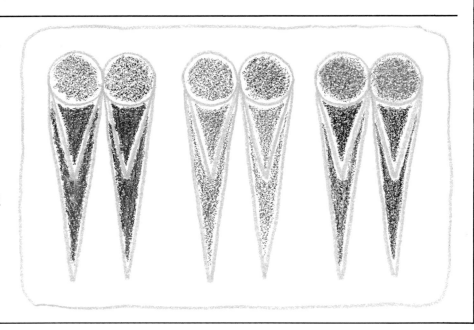

117

# 37. WORKING OUT OF THE COLOR DOLDRUMS

When working with color, it is important to keep our colors lively and fresh; if certain schemes and mixes have been successful in the past, we shouldn't rely too much on them. The same schemes and mixes in a new context may look overly familiar and cliché-ridden; and our drawings predictable and empty of the resonances they ought to have.

Working our way out of such a situation begins, of course, with acknowledging that we are in it. Assuming we are indeed in the color doldrums—and that our critical eye is now telling us so— here are three areas that we might explore in order to find solutions to this problem:
1. Visualizing Color
2. Mixing Color
3. Breaking up Color

The following ideas and suggestions have often succeeded—even with very hard cases. Let's look at them one by one.

## 1. VISUALIZING COLOR

I had been painting and drawing for several years before I discovered that when I thought of the color blue, I was really visualizing blue-violet. This didn't seem to matter too much, until I became more deeply involved with some of the possibilities inherent in altering color dimensions, and with seeking predictability in color schemes and mixes. What I gradually discovered was that a color mix that requires a blue—and instead gets a blue-violet—simply does not come out as expected.

To check on your own color visualization, try drawing enough accurate patches of color with your own color drawing medium to represent the hues of a hypothetical twelve-hue color wheel. Work with three related hues at a time so you will have a basis for comparison. Try, for example, to accurately establish a blue-green, a blue, and a blue-violet with the proper proportions of change between each two.

Another suggestion—should accurate visualizing of color be a problem—is to try making color a tangible thing when you draw. By this, I mean working from such things as fabric remnants or ribbons. It helps also—for tangible sources—to keep a sample file (in a box or drawer) of particularly interesting color mixes and schemes you have come across in magazines and the like.

## LOOKING AT COLOR

In my own studio, I keep quite a lot of colored ribbons at hand. I group these sometimes into piles of colors I'm interested in, then physically add or subtract one or two at a time for a tangible look at color results. Because the ribbons are long and narrow, they weave in and out, providing clear evidence as to how such colors will mix. My ribbons are not always fabric. Paper ribbons can serve just as well.

## STOCK DESIGNS

To try out hue schemes before planning a drawing, I sometimes make up a "stock design." I do this on regular drawing paper, and then place it under tracing paper. By moving the tracing paper around, I can apply whatever colors I am exploring right over the design, without having to draw a new design for each color change. For use with most schemes, I plan a simple design containing one dominant part and two lesser parts—one of which is less than the other.

## TESTING COLORS

With an image for a drawing in mind, I often use tracing paper to help make colors more tangible. I first make a thumbnail rough in graphite with what I think is an appropriate arrangement of elements. The rough is usually small and very simple.

I then rip a strip from a sheet of tracing paper and, laying sections of it over my rough, quickly try any color ideas I may have in mind. Testing colors at this early stage often changes a first composition, or even an original concept. It is a fast and idea-building way of working, and also a way to keep from getting bogged down with drawing new thumbnails for subsequent scheme ideas.

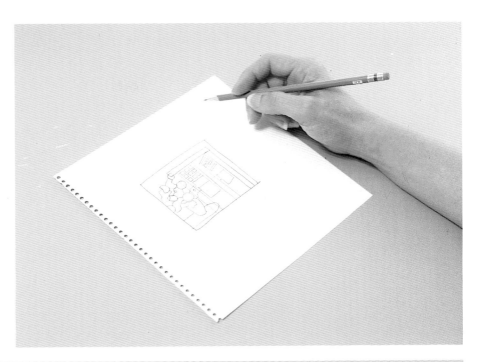

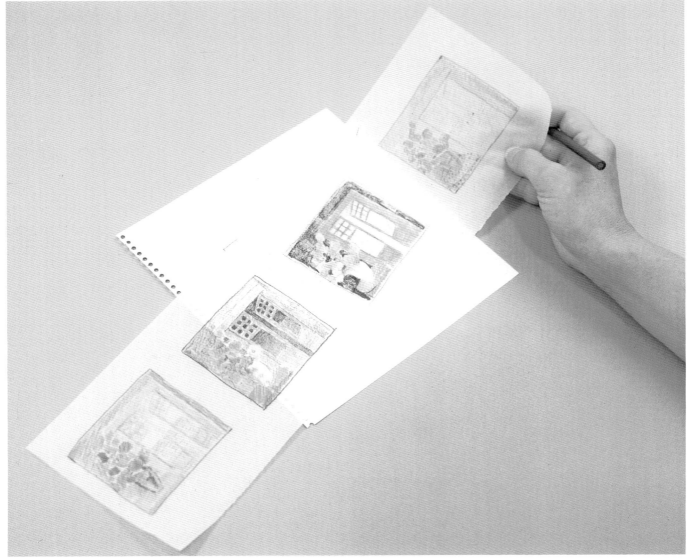

# WORKING OUT OF THE COLOR DOLDRUMS

## 2. MIXING COLOR

We fall into color-mixing clichés when we begin to mix colors too glibly and too automatically. A basic strategy for avoiding this is to reorganize the way we physically lay out our color drawing media. This may seem a mechanical, and even a silly tactic, but I am convinced that having a static and never-changing palette will just about guarantee getting more and more automatic about the colors we combine. Color mixing stays livelier when we have to look sharply at the colors we reach for. It is also important with any medium to occasionally try brands and colors other than those we always use.

And this leads to another suggestion. I now feel certain that quite a lot of poor color mixing begins as early as a trip to an art supply store. The problem which presents itself here is that color drawing media, with their pigments clearly and beautifully visible (unlike tubes of paint), are almost too attractive on racks and store shelves—which can led to buying some of them mostly for their display appeal.

Should you doubt this, notice when you're next in an art supply store how popular colors in the blue-violet-red range appear to be the fast sellers. The more obscure colors—those with names like Gunmetal, Copper-beech, and Burnt Carmine—are usually in very ample supply. As colorists, able to construct just about any color we want, we shouldn't really need to buy the colors that look the prettiest. In fact, it is with these others—those that often languish unchosen—that the most spectacular (and often unnameable) mixes are most likely to occur.

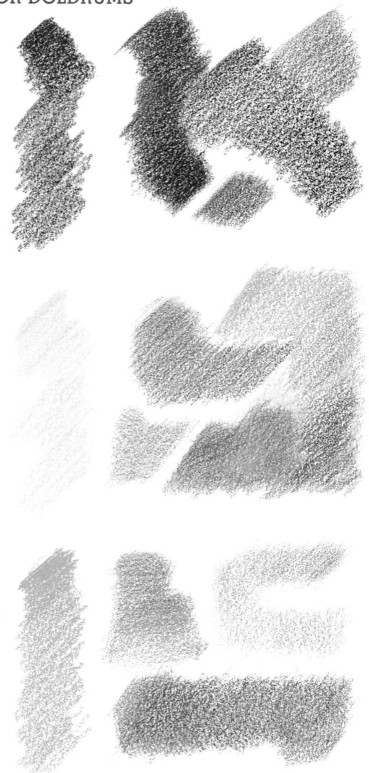

## INVENTING COLOR MIXES

These color mixtures don't have names, yet each could be useful in an appropriate situation. All were made with primary colors mixed with seldomly used colors, such as Blush, Bronze, Flesh, Terra Cotta, Slate Gray, and Gunmetal.

Mixtures like these are hard to describe verbally, unless as an "earthy-pinky-red" or a "yellowy-bluish-gray." We must always be ready, I think, to try oddball or unusual colors in our mixtures, and not limit ourselves to colors with familiar names.

## 3. BREAKING UP COLOR

There are certain situations when ideally we know what we should do but find it difficult to make a start. Breaking up color can be one of these situations.

If you are finding it hard to push color in new ways—that is, to break it up—you might want to try the grid method, a technique in which there is often a dramatic improvement—even from a single experience. We'll be working with the grid method in this lesson's drawing assignment.

### STUDENT DRAWING
*PEGGY MORRIS BISKAR. COLORED PENCIL ON PAPER.*

This student was becoming dissatisfied with her use of color, which is typified in this drawing. She was trying, she felt, to modulate hues—but tended always to fall back instead on modulating her colors only with value changes.

### STUDENT DRAWING
*PEGGY MORRIS BISKAR. COLORED PENCIL AND GRAPHITE ON PAPER.*

As a weaver, familiar with the idea of using colored fibers for a total effect, this same student started using the grid method for modulating hues. In this drawing, made with a grid, you can see how the hue changes differ from those in the earlier drawing. Compare the changes of color in the background of this one, for example, with those in the other. Once hue changes are fully experienced with the use of a grid, it is an easy step to making hue changes without one.

## DRAWING ASSIGNMENT

If you are not yet breaking up color as much as you wish, this exercise may provide the breakthrough you need. It involves color drawing with a visible grid. There are many ways of using grids as drawing aids, of course, but the purpose of this grid is solely as a method for modifying colors square-by-square.

Start by drawing your grid. On a 14″ × 17″ (35.5 × 43 cm) sheet of medium-grained drawing paper, very lightly mark off a pattern of ¼″ (.64 cm) squares. Use an ordinary HB graphite pencil, leaving about a three-inch margin all around. (For clarity of illustration, I have pressed much harder with the pencil than I ordinarily would.)

Ignore the squares as you lay in graphite guidelines for a composition within your grid. But as you begin to use color, don't use a single mixture for an element or area. Vary your mixtures instead square-by-square, changing them by hue, value, intensity, or temperature.

You will find that you don't have to sacrifice form to do this. Looking back at the completed grid drawing shown, you will note that its forms are not at all ambiguous. In fact, you may—as you vary color in various ways, and see it all come together as a whole—begin to feel more confident about manipulating color than you have ever felt before.

Here is a tip. Should you feel timid about injecting completely contrasting hues into a given area, try at first using only analogous hues. As color areas gain in complexity, you can then gradually work into hues that are more dissimilar.

# 38. MAKING GOOD COLOR NOTES ON LOCATION

Notes made on location can later prove to be inadequate and frustrating—or they can furnish you with all the information you need to finish a drawing. It has been my experience that whatever a picture's final medium is to be, colored pencils are unsurpassed for the swift and easy making of good location notes.

## EXAMPLE

These two pictures show a location and my own quickly made notes about it. I always try first to simplify a scene's masses. At the same time, I add further color observations to my indicated colors, using pencil numbers with which I am familiar.

For this setting, only eight pencils were used: two greens, two blues, two violets, an orange, and a yellow. Yet I have enough notes here to draw this landscape in my studio, using colored pencils or any other medium.

# 39. USING PHOTOGRAPHY AS A SOURCE

Photography can be a very useful tool of drawing. It can be inspiring and provide us with an enormous amount of information. It can also, however, lead to problems that we should be aware of.

It is important to understand, before you base a drawing too closely on a photograph, that photographs contain visual distortions. We accept a distorted and monocular view of the world in photographs—simply because we know them to be photographs. But possibly only in "photo-realism"—in which photography's peculiar qualities *are* the subject—that full photographic distortion can be successfully transferred to another medium.

Here are things to watch out for when photography is used as a drawing source:

1. Multiple distortions. A camera's lens can do strange things to a still life. If you are photograph-ing an arrangement to draw, be aware of the things you will have to compensate for. Elements near-est the camera may loom out unrealistically, while only slightly farther away, things may seem much too far back. Lenses also can compress or flatten the space too much.

2. Lack of subjectivity. A lens does not see in a psychological way (as we do). We can empha-size or minimize elements with ease. A good example of photo objectivity shows up in people's eyes, which are often drawn much too small when copied from a photograph. When drawing from life, artists almost always enlarge the eyes—which are psychologi-cally important to us, and power-ful clues for revealing character.

3. Photographic modeling. The light and shade revealed in photo-graphs are not the same as the modeling with light and shade used for drawing; forms copied from photographs usually look too flat.

4. Exaggerated highlights. There is a generalizing of the light range in photography. Photo-graphic highlights occupy more space, and contain less subtlety of gradation than those we see in life.

5. Converging verticals. The small cameras now in common use do not "correct" for the natural convergences of doorways, win-dows, and buildings. Transferred to a drawing, the "leaning build-ings" of a photograph will look quite false.

6. Photo colors. These are fre-quently too vivid and too unmodu-lated. In many photographic post-cards, and in posters particularly, oceans and skies may be slabs of acidic blue—and whites too pink or too green.

## EXAMPLE 1: DISTORTIONS

Here is a photograph containing multiple distortions. A first prob-lem you might encounter from this too-close view would be the bal-looning of the bananas. Among other problems are the little cam-era's severely tilted vertical lines, and the swiftness with which the patterned background appears to diminish in size.

## EXAMPLE 2: COMPRESSION OF SPACE

The big problem with this kind of photograph as a drawing source is its compression of space. Everything appears flattened and too jammed together. The onions and basket lack the roundness they should have. There are also other confusions of form, including a lot of ambiguous detail in the slicer reflections.

## EXAMPLE 3: THE POWER OF PHOTOGRAPHY

Pictures like this one are "grabbers," and can tempt us to try drawing directly from them. The problem here—in addition to a few of the "making art from art" problems discussed earlier—is that the doll's face is only photographically modeled. Copied closely or traced, it would not contain enough modeling with light and shade to reveal its form; its strength as a photograph would pale as a drawing. This is a particularly good example of a photograph's power to persuade us with its own reality.

## EXAMPLE 4: SPATIAL CONVERGENCES

Here is the "building-leaning-backward" convergence which happens when a camera points upward. Variations of this phenomenon can happen with windows and doors—even tables and chairs. What we need to remember, when correcting information of this kind for drawing, is that there are more convergences in some photographs than is immediately apparent. With leaning buildings, for example, every window, every doorway—perhaps every brick—may be similarly affected by distortion.

# 40. COLOR DRAWING PROJECTS

The following projects might more accurately be called ideas. Their aim is to set up a structure for growth through practice, so try as many of them as you can, as personal time and energy permit. A few are designed for specific media, but most can be done with any color drawing medium you choose.

## 1. DRAWING VEGETABLES WITH LINE AND TONE

*COMBINING COLORS IN NEW MIXES, RATHER THAN RELYING ON MANUFACTURERS' COLORS*

STUDENT DRAWING, Cyndy Heisler. Colored pencil on paper.

Most vegetables are very forgiving as subjects. They are organic (not machine-made) and their forms, texture, and color can vary a great deal. Arrange some vegetables on a table or in and around a container. Be sure you can sit or stand comfortably to draw, without twisting or craning to see your setup.

Use a gestural line for this project, letting colors knit together as complex tones. Draw contours freely and loosely. You won't need graphite guidelines, because you are after a spontaneous response.

# COLOR DRAWING PROJECTS

## 2. MINIMAL GRID DRAWINGS

*ASSESSING HUE, VALUE, AND INTENSITY OF COLOR—THE BASIC SKILLS NEEDED FOR COLOR DRAWING*

This project has four parts, and its complexity is up to you. I've seen it in small workbook versions and as large-sized ambitious drawings. The idea is to use color differently in each of four grids. (Making a basic grid is described on page 122).

For your first grid, use only one hue (working with more than a single pencil if you like). Vary the hue's value, but only its value. In your second grid, use analogous hues, but this time try to keep all their values and intensities very similar. In your third grid, use a variety of hues, again keeping values and intensities similar. (You will note that sharp hue contrasts often read as contrasts in intensity. Be alert to this illusion).

For your fourth grid, anything goes. Vary all three color dimensions as you move from square to square. You'll find that unity and stability are hard to achieve with this much freedom, but you'll get a good workout.

## EXAMPLE: GRID PORTIONS

These are portions of grids, and correspond to the uses of your four grids. Remember when working with grids that you can also vary the ways in which color is applied in the squares. Although I have filled whole squares tonally, you can also use hatching, or even just a spot of color in a square.

## 3. LOW-KEY SELF-PORTRAIT
*KEEPING VALUES LOW, YET HUE-LADEN*

If you want realism, use a fairly large mirror. If realism is not a concern (the image will not be consistent in angle or viewpoint), use a small hand-mirror. Don't use a photograph.

Also, don't try for low key by drawing in a darkened environment. Achieving this effect depends more on a concept than on presence of light; it is a matter of keeping color dark in value, but still rich in hue. Darken your colors by mixing them with other colors whenever you can, rather than by mixing with black.

Think, too, of a dark background for this kind of portrait. Bring its darkness into face and neck areas, letting only important contours emerge into light.

## 4. PATTERN OF GRAYS
*SEEING NUANCES AMONG COLORS OF LOW INTENSITY*

Begin by finding a piece of fabric that has a brightly colored pattern or design. This pattern will be the source for your drawing, but instead of using the fabric's original hue scheme, change the bright colors to various hue-laden grays.

Remember that the pattern's designer relied on contrasts for defining separate elements. To do the same—working only with hue-enriched grays—you must continue somehow to suggest these contrasts of hue and value.

## 5. TREE DRAWN WITH COLOR STRUCTURE
*MAKING COLORS ADVANCE AND RECEDE*

From your imagination, draw a bare tree—a winter tree with no leaves, only bare wood, and branches reaching out into areas of space. Work with color and negative space from the very beginning.

We think normally of bare winter trees as having a fairly specific color. But thinking as a colorist—that is, making color suggest positions in space—you must now modulate this "tree color" accordingly. Branches nearest you must be warmer and/or brighter than those farther back. You will also have to integrate the branches that are farther back with negative space and cooler colors in order to help make them recede.

## EXAMPLE: BRANCHING TREE
Keep your branching tree simple. Concentrate on using color for spatial structure. In this line drawing without color, the tree and its branches all remain pretty flat.

# COLOR DRAWING PROJECTS

## 6. DRAWING ON MYLAR

The Mylar you'll need is a translucent plastic material sold in art supply stores. Begin with any size you want, but be sure one side of it is slightly frosted and dulled. This is the side you will draw on. Because it is almost transparent, you will have to slip a sheet of white or colored paper under it to see what you are doing better. And the color of this sheet will also influence your color mixing.

With a sheet of paper behind the Mylar, you can view your finished drawing from front or back—as drawn on the frosted side, or in reverse through the glossy side. You can also erase all or part of what you have drawn using a wet cloth or tissue.

## 7. ENVIRONMENTAL STILL LIFE
### IMPRESSING LINE AS AMBIENT TEXTURE

Arrange a still life including some part of your room. Place objects on a table near a window, for example, or include the floor near a base moulding and electrical outlet. Stairs and built-in shelves can also be good environmental elements. Arrange a composition with preliminary thumbnail sketches, then lay in light graphite guidelines for it on your regular drawing paper.

As a next step, think of ways in which an ambient texture could relate to your subject and background. Here are some suggestions: a repetition of impressed lines might be used throughout—in subject as well as in negative space; or, these marks could occupy negative or positive space—but not both. The first way can be an important clue to mood, depending on the mark used. The second tends to yield a more decorative feeling. (Check pages 76 and 77 to review how lines are impressed.)

With the lines you have chosen impressed into your paper, you are ready to begin drawing tonally. Remember as you complete this still life that the more pigment (or pressure) used for tones, the more your impressed lines will be revealed.

## EXAMPLE: DRAWING ON MYLAR

An almost transparent Mylar sheet is shown here over a sheet of white paper and a sheet of a middle-toned gray. As a color drawing surface, this material provides an interesting experience. Although pencil colors mix and overlay on Mylar as they do on a regular drawing paper, the pigments feel much softer.

Because it is also a nonabsorbent surface, lines drawn on Mylar can be "erased" with a solvent. Here, I have used water and a cloth to remove a water-soluble color. Non-water-soluble pigments can be removed in the same way with turpentine.

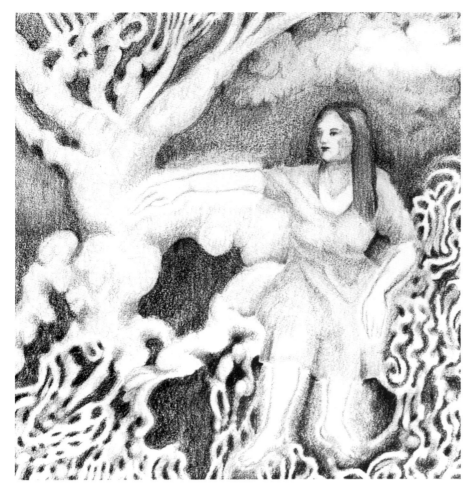

STUDENT DRAWING, Suzan Dahlstrom.
Colored pencil on paper.

## 8. OBJECTS WITH EMANATING LIGHT

### RENDERING SOMETHING FAMILIAR IN A NEW WAY

In Lesson 20, we worked with light emanating from candles. But objects that don't ordinarily glow can also seem to emanate light—and with an almost supernatural quality.

The figure in the student drawing (see above) has glowing limbs. For a drawing of your own, plan to have two ordinary objects appear to emanate light. Try to suggest a difference in how they glow—perhaps with a cool and a warm light. A variation of this is to think in terms of objects reflecting colored light—like the glow of colored neon.

## 9. METALLIC OBJECT, HAND-HELD

### LOOKING CAREFULLY AT A METAL SURFACE

Choose an object made of metal and hold it in your free hand as you draw it. Tools such as pliers and wrenches are good subjects, because their lines are simple and strong. But any metallic object will do.

Because metal can be intimidating to draw (if reflective), or too uneventful (if nonreflective), try enlarging your chosen object so that very little negative space remains. This will encourage you to really focus on it—and see the visual events happening on the metallic surface.

## 10. BRUSH DRAWING

### DRAWING WITH A BRUSH, AND DRAWING GLASS

A flower in a glass of water provides a combination of forms well-suited to both the flow of a very gestural brush stroke, and to a more controlled dry stroke. With a single flower in a glass about three-quarters full of water, test various backgrounds for revealing the glass contours and the flower's stem. Sometimes a pattern works well for this.

Use a paper resistant to buckling. If you plan to use turpentine as a solvent for your brushwork, you may also want to first lightly coat your drawing paper with a protective coating of clear acrylic spray varnish.

## 11. BIOGRAPHICAL SELF-PORTRAIT

### TELLING SOMETHING ABOUT YOURSELF

For this project, you must think of something that visually fits in with your own portrait, and also reveals something significant and unique about you. This can be a tangible thing, maybe suggesting your work or your goals, or it can be something that has influenced you greatly.

# COLOR DRAWING PROJECTS

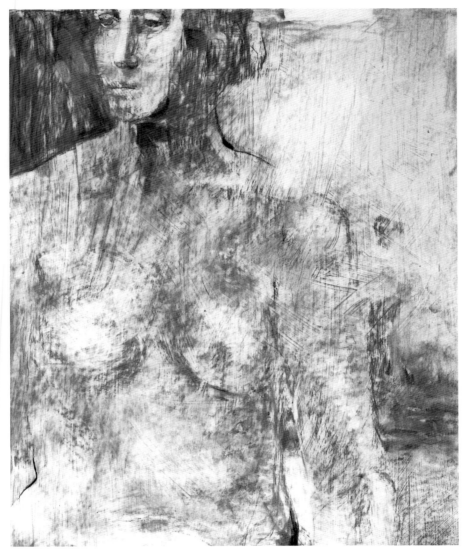

STUDENT DRAWING, Elizabeth Weston.
*Colored pencil on paper.*

## 12. DRAWING ON GESSO

As another change of surface, try drawing on paper prepared with gesso. For this drawing, I used pastel on a single coat of acrylic gesso applied to tagboard. This brushed on and unsanded synthetic gesso makes a nice surface, and one that seems to encourage looseness.

Colored pencils and graphite can also be used with a gesso, but sanding the surface is recommended. With fine garnet paper and four or more coats of a traditional gesso, a truly exquisite drawing surface can be made for pencils.

If you'd like to prepare your own traditional gesso, here is a recipe:

   1 qt. cold water

   3 oz. (dry measure) rabbitskin glue (available from art supply stores)

Whiting—as needed (available in various forms from paint or ceramics suppliers)

Drawing paper—good quality.

To use, pre-stretch the paper by taping it to a board or wall and moistening it with water in a wrung-out sponge. When the paper has dried, add the rabbitskin glue to the quart of water, heating the water in a double-boiler arrangement until it is hot (but not boiling) and the glue is thoroughly dissolved. Add whiting while stirring, until the water/glue mixture becomes white and of a light creamy consistency.

Apply four or five coats of this gesso to your paper (letting it dry between coats) with a thin flat brush. When the final coat is thoroughly dry, sand it lightly with a very fine garnet paper.

## 13. USING COLOR AS A "COMMON DENOMINATOR"
### *UNIFYING A LANDSCAPE WITH COLOR*

Try drawing a simple landscape using and re-using one color of pencil or pastel in all the color mixing you do. To help decide which color to use as a "unifier," experiment first with some sample patches. Although you can vary the amount of your "common denominator" color in mixes, it must be included in everything, including the sky.

## 14. MODIFIED SELF-PORTRAIT
### *INTEGRATING SEPARATE ELEMENTS*

The idea in this self-portrait is to smoothly substitute an object of some kind for one of your facial features. To do this convincingly, use the concepts discussed in Lesson 35 for integrating a subject with its background. Besides using edge tie-ins and blurring of contour edges, it helps also to use an object somewhat similar in shape to the feature it is replacing.

## 15. SENSORY STUDIES IN COLOR
### EVOKING A MOOD OR IDEA

With a neutral color, divide a large sheet of paper into four parts. Use each part for a separate drawing designed to evoke in turn feelings of sound, taste, smell, and touch. Don't rely on showing objects representationally for this, but work more abstractly, relying on suggestive powers of color, shape, and position.

As you approach each sense, try to summon up your own essence of it, then think how you might translate this to a visual clue. To score yourself, ask someone else to try guessing which sense is represented in each drawing.

## 16. A ROOM IN TRIADIC COLOR
### WORKING FROM A HUE SCHEME RATHER THAN LOCAL COLOR

Our powers of observation grow sharper as we learn to freely and at will change the colors of a reality to those of a deliberate scheme. The way to do this effectively—without losing the sence of an original scene—is to carefully assess the dimensions of colors being changed.

For practice at this, prepare to draw a room or part of a room in your own house or apartment. But instead of using the colors you see, confine your mixes to just three colors—the triadic scheme of yellow-orange, red-violet, and blue-green. With Prismacolor pencils, for example, this would mean a 918 Orange, a 931 Purple, and a 905 Aquamarine. The thing to remember, as you use these colors (unmixed or in combinations), is that the contrasts and values of your scene will not be changed. The only color dimension you are really changing is hue.

## 17. FULL FIGURE ON BROWN PAPER
### CHANGING SCALE

The aim here is to draw one or more figures larger than life-size. Regard this as a loosening up exercise, and use one of the stick-form color media for it.

You will need brown wrapping paper—available at variety or stationery stores. This paper is not usually wide enough for me, so I tape (from the back) a pair of additional side panels to the main piece. My drawing here is in pastel, and is about 3 ft. wide by 6½ ft. high (91.4 × 228.6 cm).

Before setting out to draw on your large sheet (fastened to a wall with masking tape), work out a composition and color ideas with thumbnail roughs of the same proportion. Try to keep your subject figure simple and large within its frame of reference.

Pastel on paper.

133

# APPENDIX

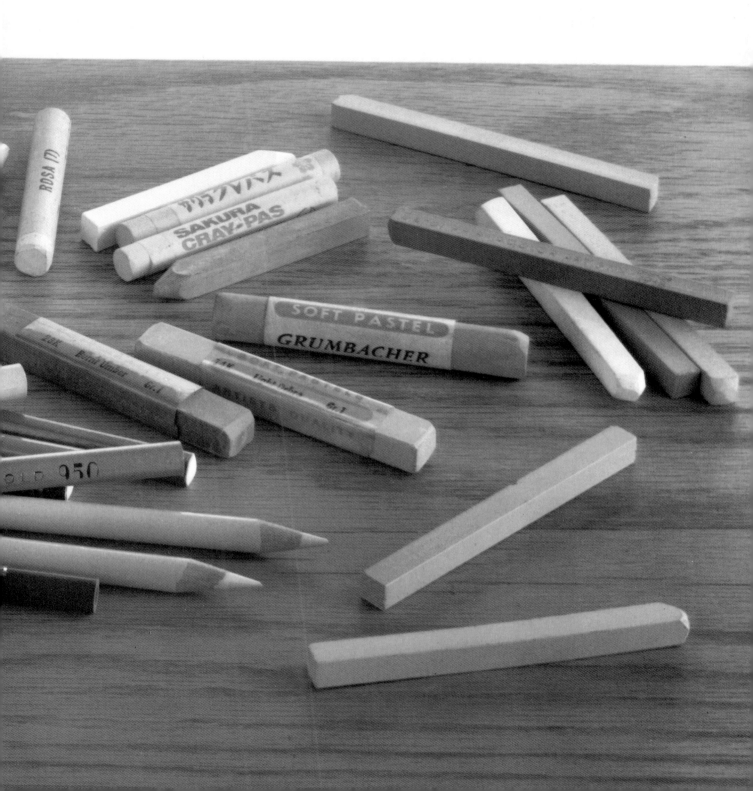

# MATERIALS LIST

An additional benefit of color drawing is that the materials and equipment needed for it are simple, readily available, and inexpensive.

The following listing covers all the tools needed for our drawing assignments. In some cases, specific brand names are used because for me they have worked particularly well. However, always feel free to make your own choices.

## COLORED PENCILS

You will want an assortment of fine art quality colored pencils. Brands vary in the permanence of their pigments, the quality control in their manufacture, and in the "feel" of them in use. Also, some manufacturers offer more vivid colors than others. As time passes, you will want to compare different brands for yourself to see how each meets your own needs and preferences.

The following assortment of Berol Prismacolor pencils—the brand whose numbering system is used in this text—may offer you a start:

ESSENTIAL
901 Indigo Blue
903 True Blue
905 Aquamarine
908 Dark Green
910 True Green
911 Olive Green
913 Bice Green
916 Canary Yellow
917 Yellow Orange
918 Orange
922 Scarlet Red
924 Crimson Red
931 Purple
932 Violet
933 Blue Violet
937 Tuscan Red
938 White
943 Burnt Ochre
947 Burnt Umber

OPTIONAL—BUT VERY USEFUL
902 Ultramarine
907 Peacock Green
914 Cream
929 Pink
936 Slate Gray
942 Yellow Ochre
949 Silver
956 Light Violet
968 Cold Gray Very Light
948 Sepia

*Note:* whatever pencil brand you buy, get into the habit of checking to see that the leads are well centered in their shafts. A well-centered lead makes sharpening much easier. Also, be careful not to drop colored pencils; leads can be fractured inside the wood.

## COLOR STICKS

Some colored pencil manufacturers also offer their pencil pigments in a broad-tip style. These sticklike colors match the pencil colors in name and number, and large areas can be more quickly established with them than with pencils. Recommended colors for these are the same as for pencils.

## SOFT PASTELS, OIL PASTELS AND CRAYONS

There is a large variety of other color drawing media than pencils in stick form. Although it is convenient to list all of them under a single classification, in reality they are quite different, and the separate brands among them also require some differences in handling.

Soft pastel offers a truly exquisite color drawing medium. In color, character, and permanence, it is unsurpassed. Its big drawback, however, is its soft and powdery nature, which makes it fragile and messy.

Over the years, manufacturers have formulated similar tools that try to avoid pastel's dustiness by use of a variety of binders. These are the oil pastels and crayons, which differ from soft pastels in handling and "feel." Before you buy a huge array of pastels or crayons, experiment to see if a particular brand's idiosyncrasies feel comfortable to you.

A good start is to plan an initial color selection around a twelve-hue color wheel, plus a few earth colors and neutrals. An important thing to remember about these media is that—unlike colored pencils or their broad, sticklike cousins—pastels and crayon are opaque. Their colors are mixed mostly by juxtaposition rather than by layering.

# SOME BASIC TOOLS

### SHARPENERS

A small hand-held sharpener of the replaceable blade type is an excellent tool for maintaining pencil points. A piece of sandpaper works well for shaping the ends of pastels and sticks.

### DRAWING PAPER

For most color drawing media, paper with a "tooth" is best. A medium-grained surface of this kind takes color by filing off tiny particles of pigment material. Colored and toned drawing papers can also be very effective with pastels and colored pencils.

### ERASERS

Although color drawing media can seldom be easily erased, there are two kinds of erasers you will find very useful—a white plastic and a kneaded. The plastic eraser can clean up margins and remove color that has been very lightly applied. But its true use is as a "mover" of color. (See page 74 for a fuller explanation of this interesting technique.) The kneaded eraser can lighten values with almost all color drawing media. Used with a firm flattening of the eraser, it can lift out almost entire passages. With a gentle tapping action, it can also make very slight value modifications.

### KNIFE, RAZOR BLADE

An X-Acto type knife and a single-edged razor blade are basic tools in color drawing. A sharp knife quickly whittles chisel-shaped points on pencils or stick media when these are wanted. Razor blades are used in various sgraffito techniques. And either kind of blade, used broadly, can "erase" or scrape away most of a color layer from a surface.

### CLEAR ACRYLIC SPRAY

Papers on which oily stick media are to be used should first be protected with a coating of clear acrylic varnish. Such varnish is readily available as a matte spray at most art supply stores.

### GRAPHITE PENCIL

A medium HB or B works well for most color drawing preliminary work.

### FIXATIVE

With colored pencil work, two or three very light coats of sprayed-on fixative will prevent "wax-bloom"—an exuding of excess wax to a drawing's surface. The powdering of soft pastel can also be inhibited with a spray fixative. But this last must be *very* lightly done, or the sparkle of the pastel colors will be lost. As a general rule, all fixatives should be tested on sample swatches before being used on actual artwork.

EBERHARD FABER
Kneaded Rubber

USED KNEADED ERASER

STAEDTLER

WHITE PLASTIC ERASER

# WET COLOR DRAWING MEDIA

## WATER-SOLUBLE PENCILS AND STICKS

There are a great many of these available, under various brand names. A modest twelve-pencil set will provide enough color for an introduction to brush drawing. If you decide to further pursue this kind of color drawing, you can then select a wide assortment of pencils based approximately on colors listed under "Colored Pencils," on page 136.

## TURPENTINE

You will need this stronger solvent (and a small container for it) if you want to work wet with waxy or oily color drawing media. Be sure if you use turp to have good ventilation.

## BRUSHES

For water-soluble media, any good watercolor brush is suitable. As a beginning, a #10 round sable type is recommended. For working with turpentine, however, a stiffer brush better manipulates the pigment. Try a #2 flat white bristle, and a #3 round white bristle.

## PAPER

The kind of paper to use with wet media depends on how much solvent will be used. When working with turpentine, for example, brush drawing tends to be on the dry side, and a regular drawing paper can be used. Water as a solvent usually promotes wetter techniques. A watercolor paper works best here because it is designed to avoid buckling. However, colored papers do not work well with either solvent.

## UNPIGMENTED MARKER

The tool cited in this text is Eberhard Faber's Colorless Blender #311; it is part of their "Design Art Marker" series.

# SUGGESTED READING

Here are some books and articles about color, expression, and drawing that I have found particularly informative.

## COLOR

Birren, Faber (ed.), Van Hagen, Ernst (trans.), *The Elements of Color; a Treatise on the Color System of Johannes Itten;* Van Nostrand Reinhold, New York, 1970.

> This slim volume contains an excellent condensation of Itten's comprehensive book on color theory, *The Art of Color.*

Loran, Erle, "Cezanne's Color," *American Artist,* Sept. 1953, p. 54.

> In an excerpt from the author's book, *Cezanne's Composition,* a brief look is given at how a master colorist used the physical properties of color to organize elements spatially.

Sargent, Walter, *The Enjoyment and Use of Color,* Rev. Ed., Dover Publications, Inc., New York, 1964.

> This modest paperback is among my favorites. Because it contains almost no color (for this revised edition, seven color plates have been added by its publisher), Sargent deals with color throughout in *written* terms—and conveys his ideas about the workings of color in his own style of sharp, clear prose. He also offers us several interesting passages and quotes from John Ruskin and other such past writers, artists, and scientists whose comments and thoughts are no longer generally available to us.

## COMPOSITION/EXPRESSION

Arnheim, Rudolph, *Art and Visual Perception: A Psychology of the Creative Eye,* Rev. Ed., University of California, Berkeley, 1974.

> In this fascinating and challenging book, many connections are made between how we physically perceive things and how we communicate these perceptions in art.

Cochrane, Diane, "The Teachings of Hans Hoffman: Push and Pull," *American Artist,* Mar., 1974, p. 26.

> In this illustrated article, the author presents a clear distillation of Hoffman's ideas about compositional space and about how flatness can register depth.

## DRAWING

Hale, Robert Beverly, *Drawing Lessons from the Great Masters,* Watson-Guptill Publications, New York, 1964.

> This book seems to me an essential one for anyone seriously interested in drawing. In it, Hale—who has taught for many years at the Art Students League in New York—offers a series of brilliant analyses of how the masters worked with the figure. The material is so clearly presented, visually as well as verbally, that its concepts and solutions to problems can be transferred to any kind of drawing.

# INDEX

Edited by Candace Raney
Designed by Jay Anning and Areta Buk
Graphic production by Hector Campbell
Text set in 10-point Memphis Light